Beaufort West

Beaufort West │ Mikhael Subotzky │ Essay by Jonny Steinberg

Beaufort West Prison, 2006

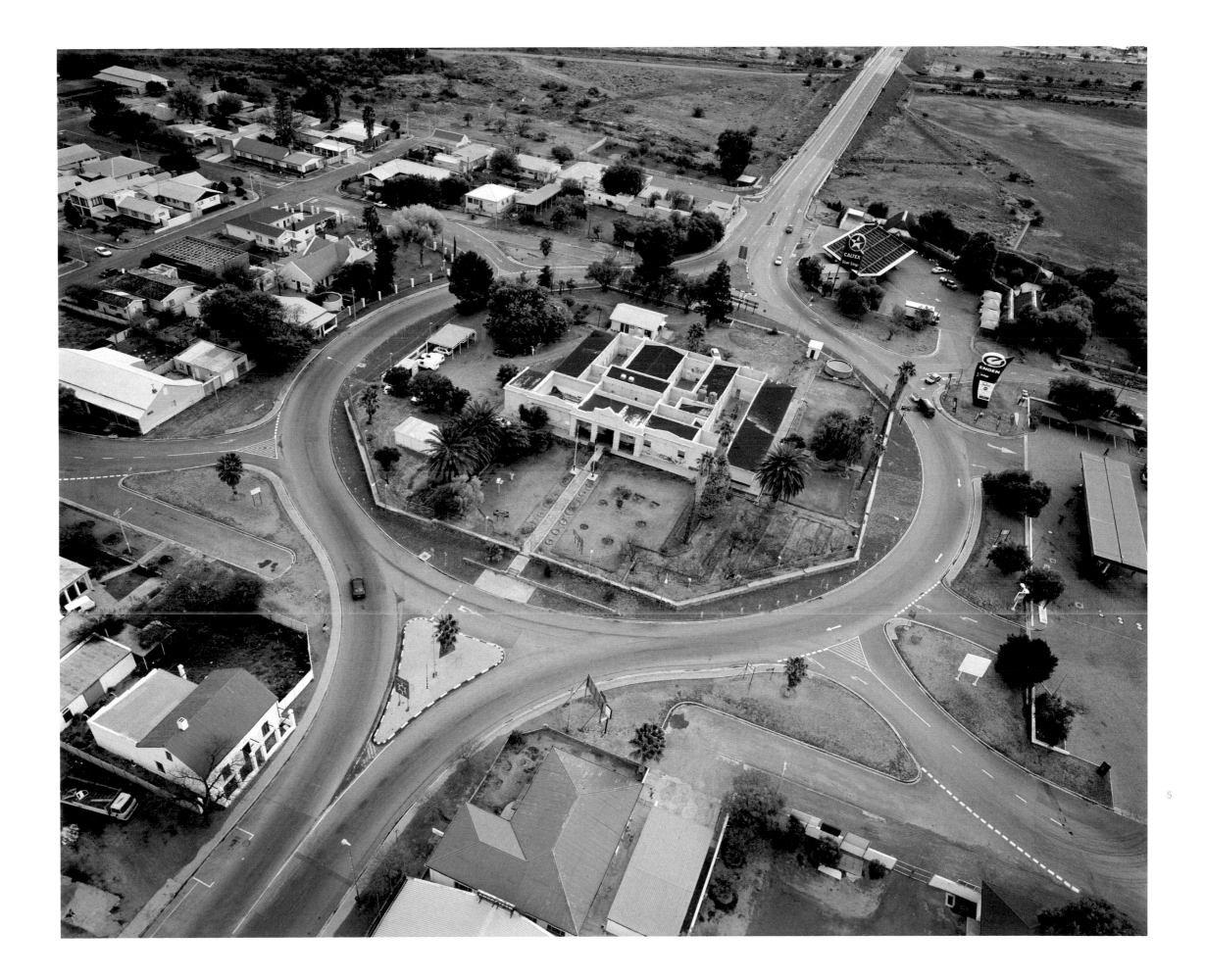

Toekomsrus, 2006

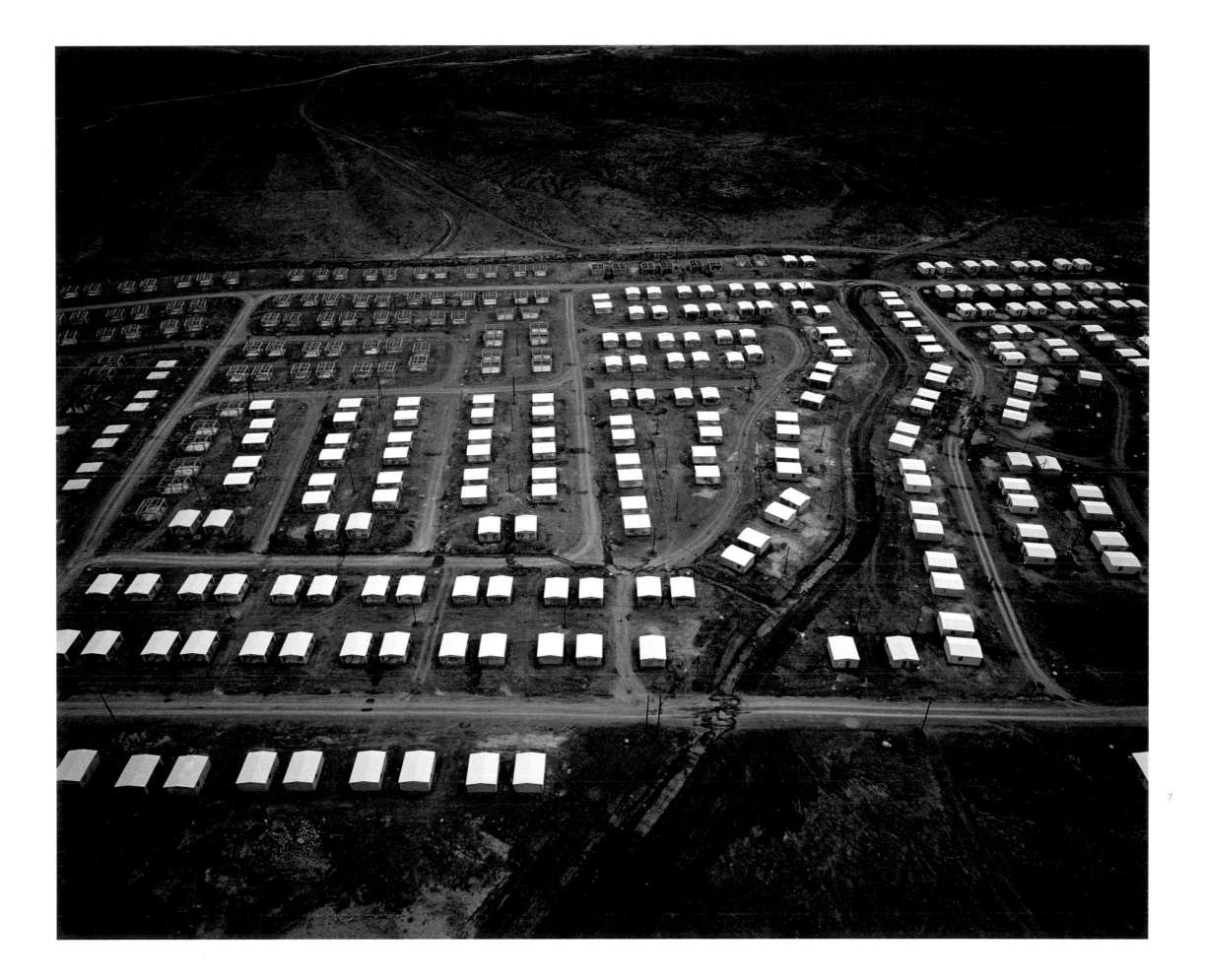

8 Motel near the truck stop, 2006

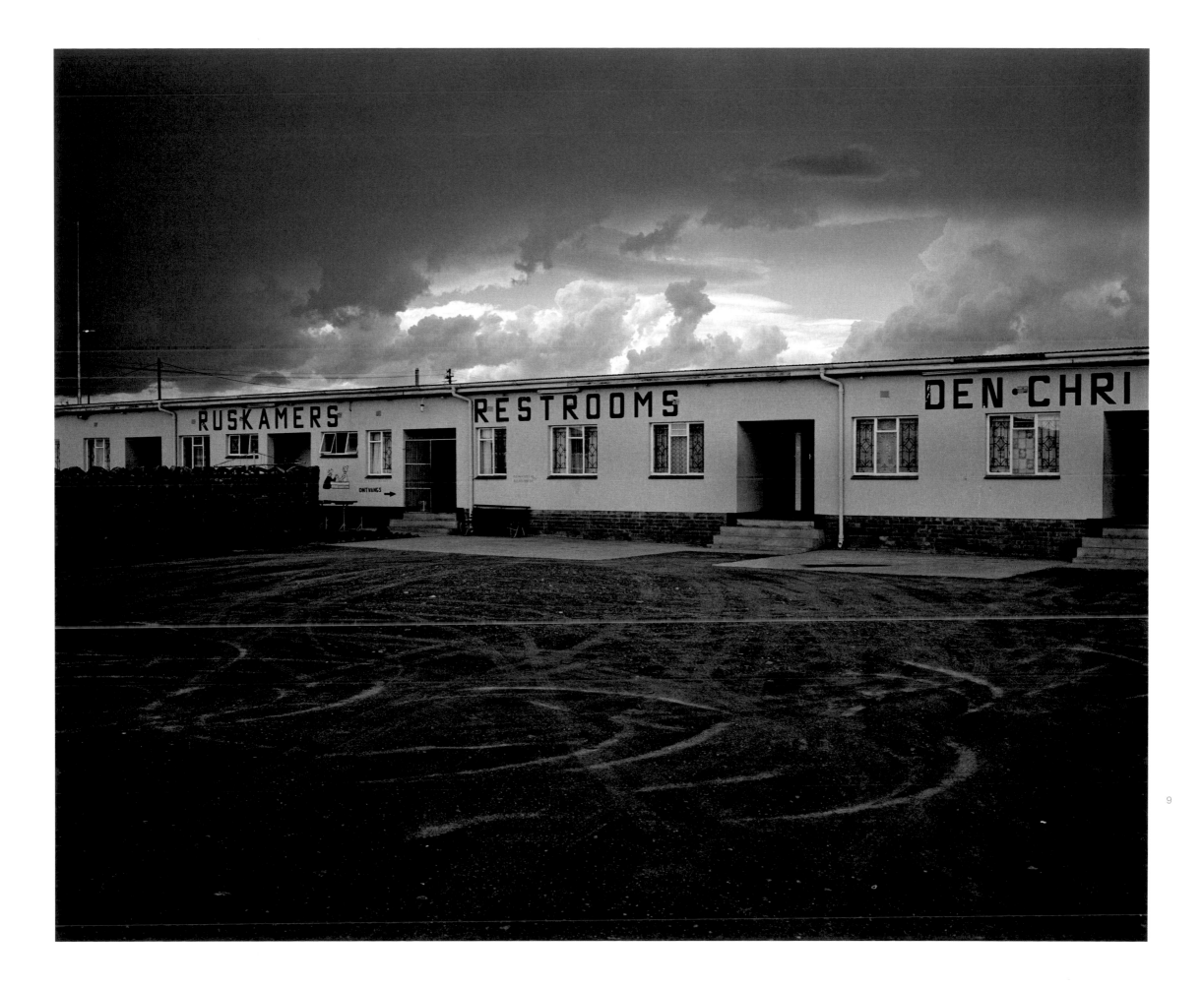

Children outside Toekomsrus, 2007

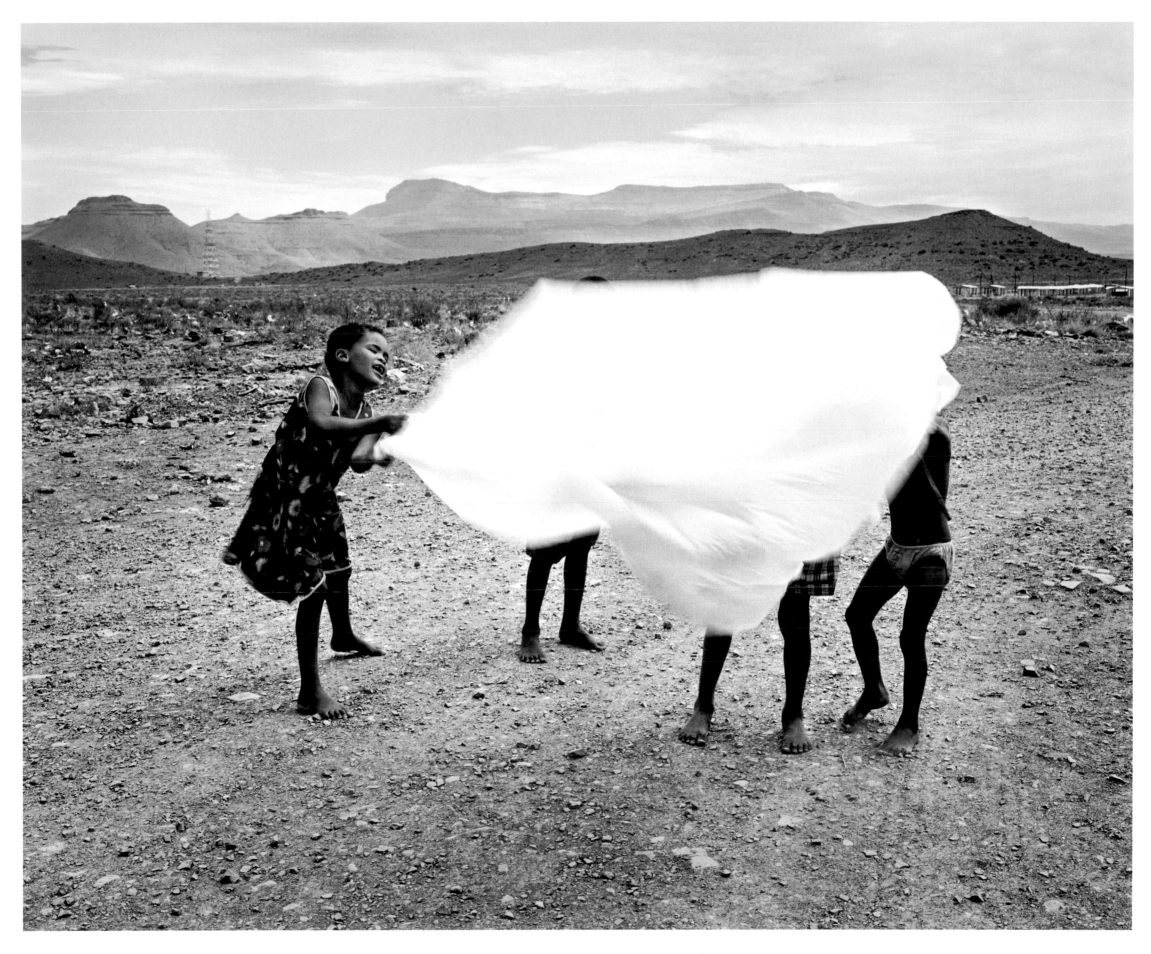

Opposite Samuel, Vaalkoppies, 2006 | Page 14 Residents, Vaalkoppies, 2006 | Page 15 Donkey cart, Vaalkoppies, 2006

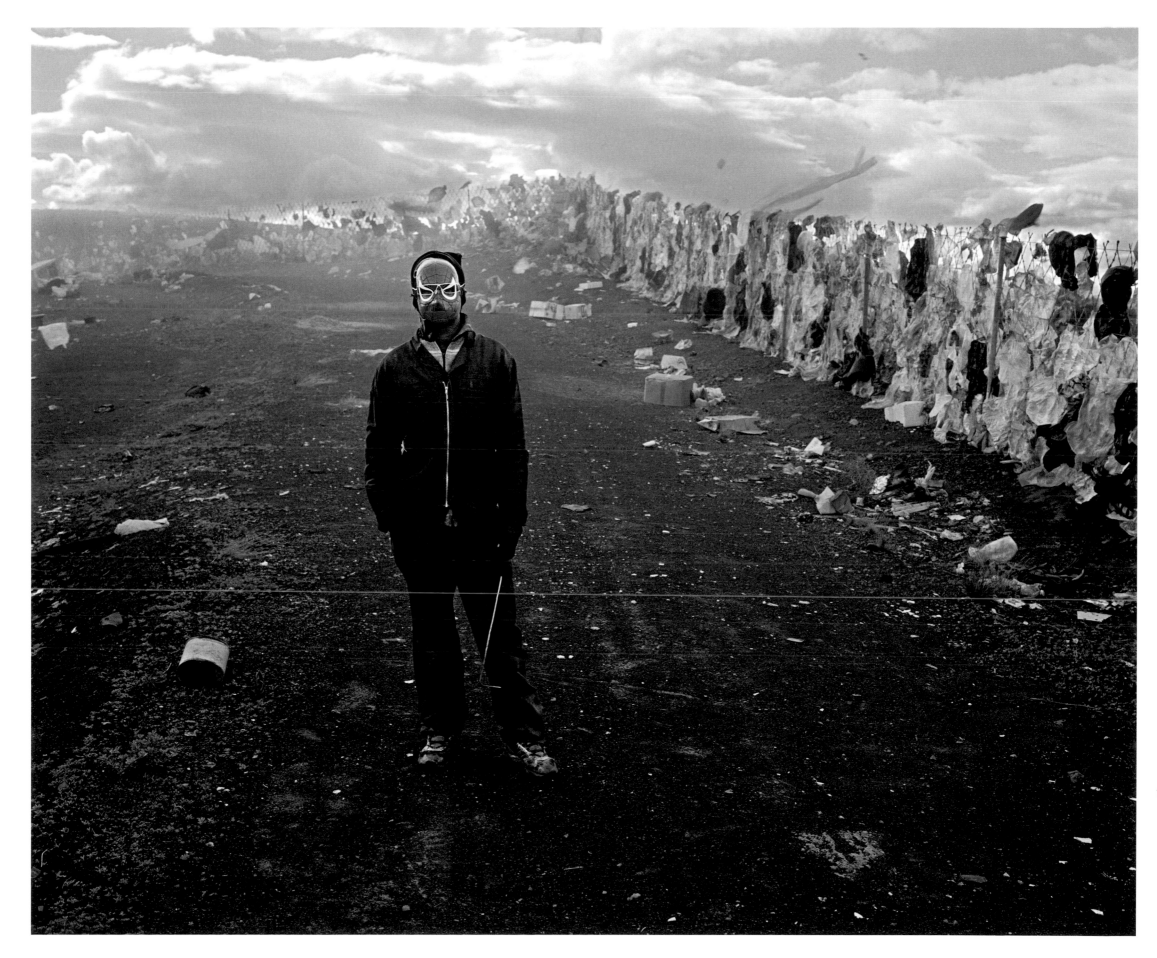

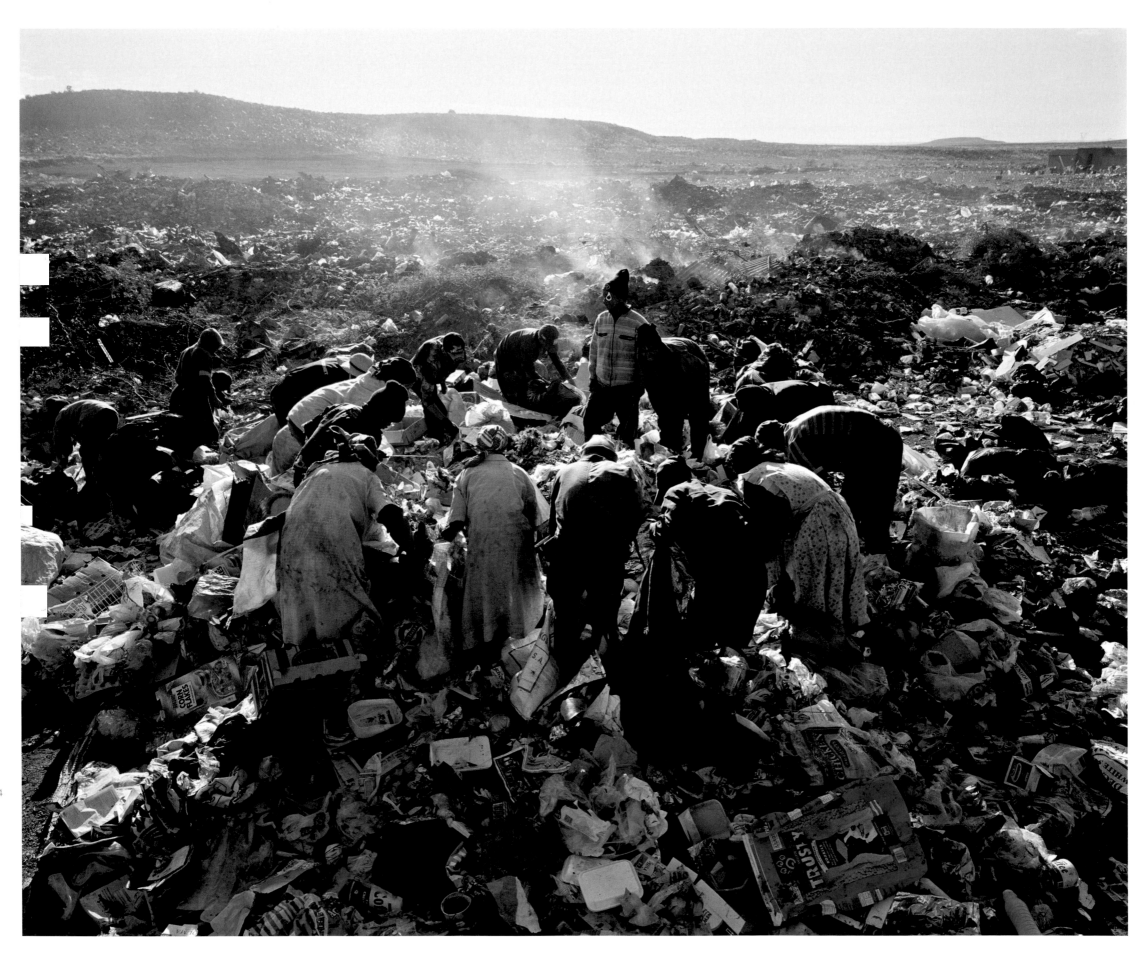

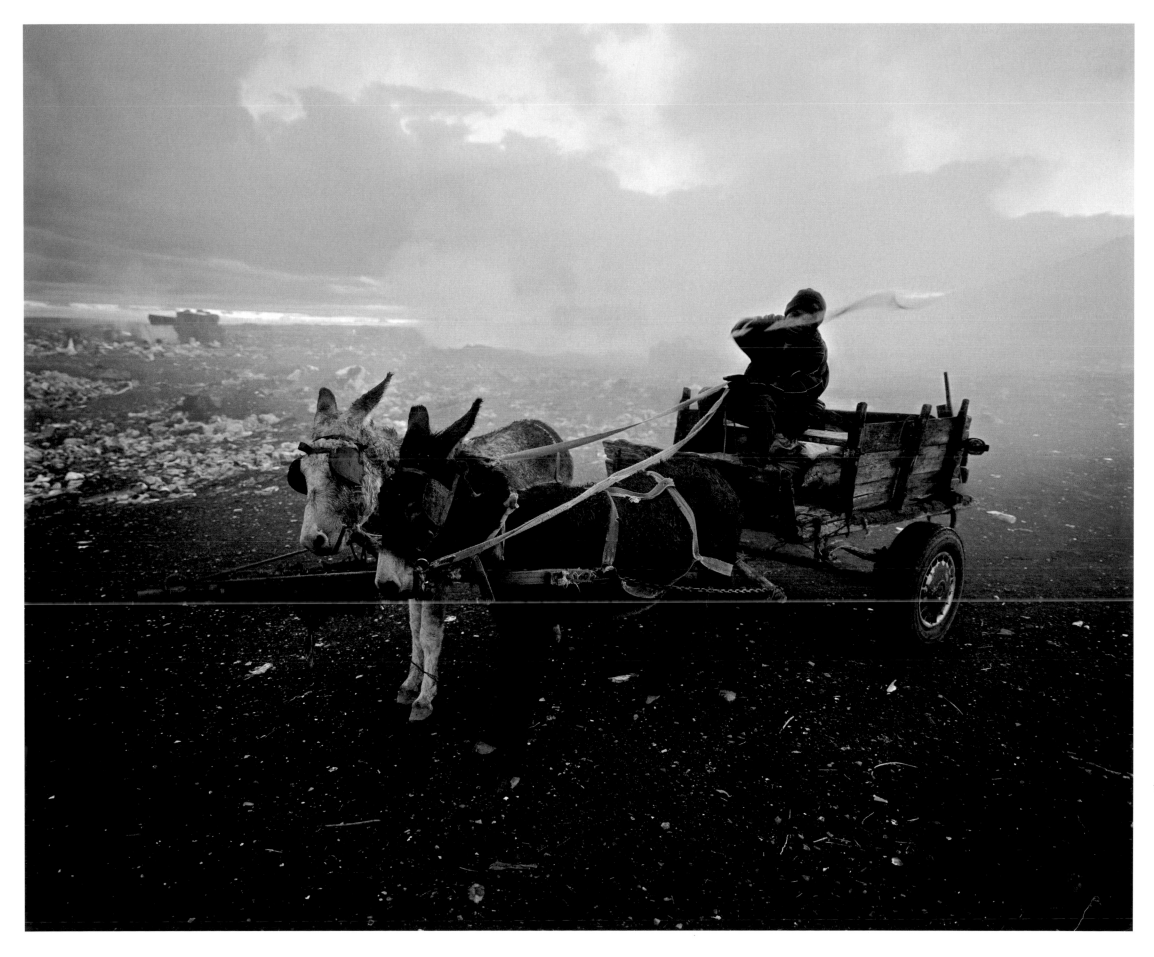

16 Fancy-dress competition, Beaufort West Agricultural Show, 2007

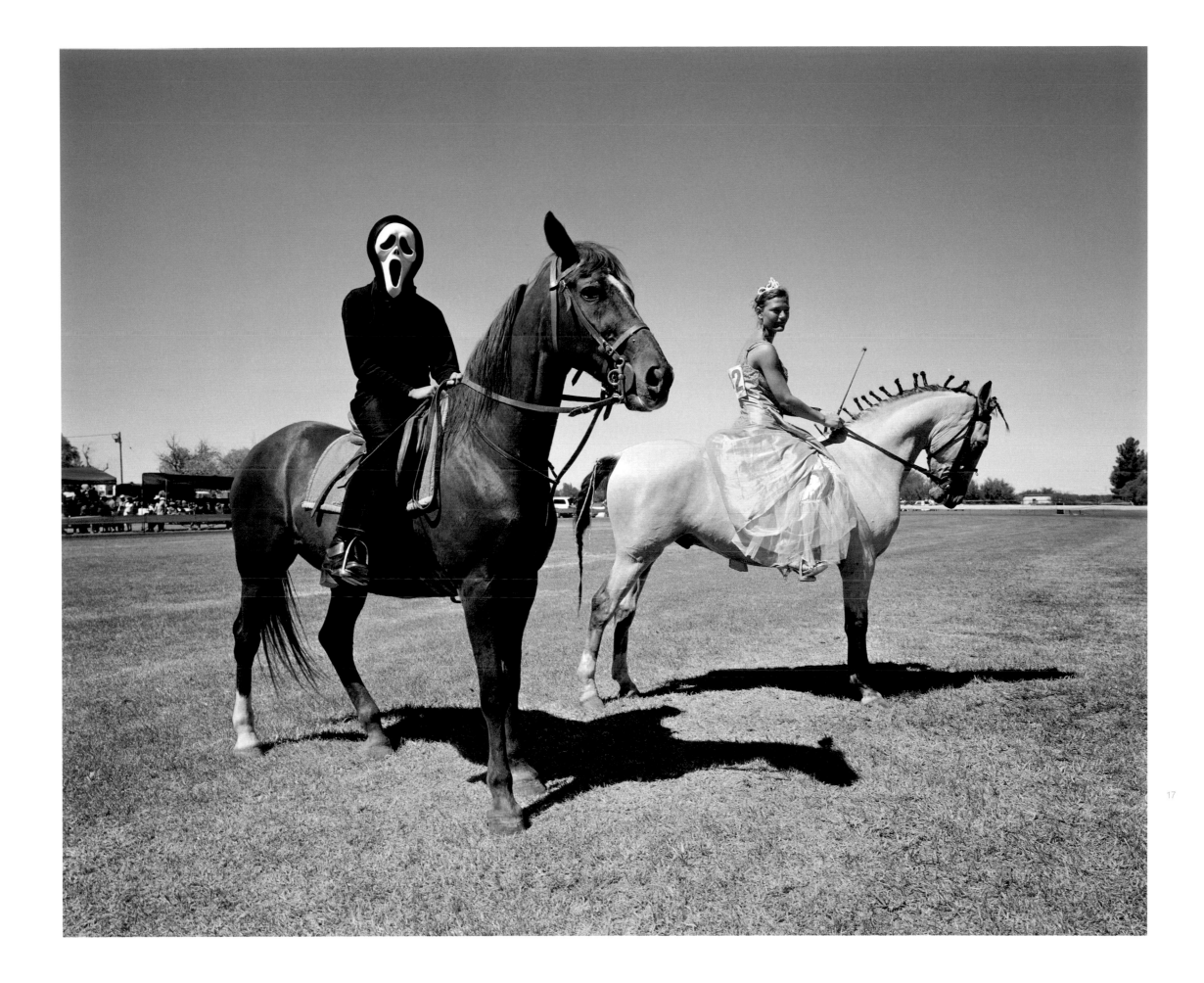

Opposite **Spectator, Beaufort West Agricultural Show, 2007** | Page 20 **Spinning class, off Donkin Street, 2007** | Page 21 **Jackal hunter, 2007**

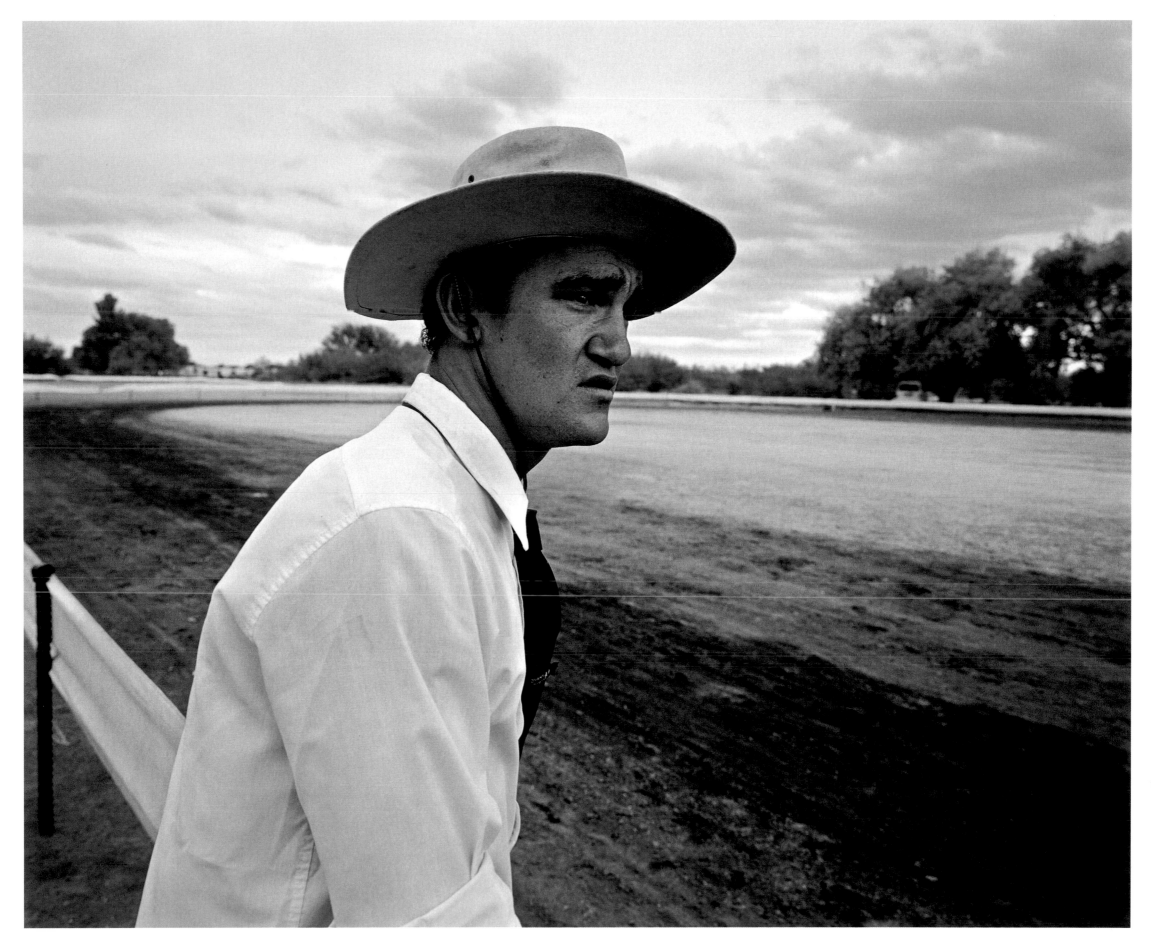

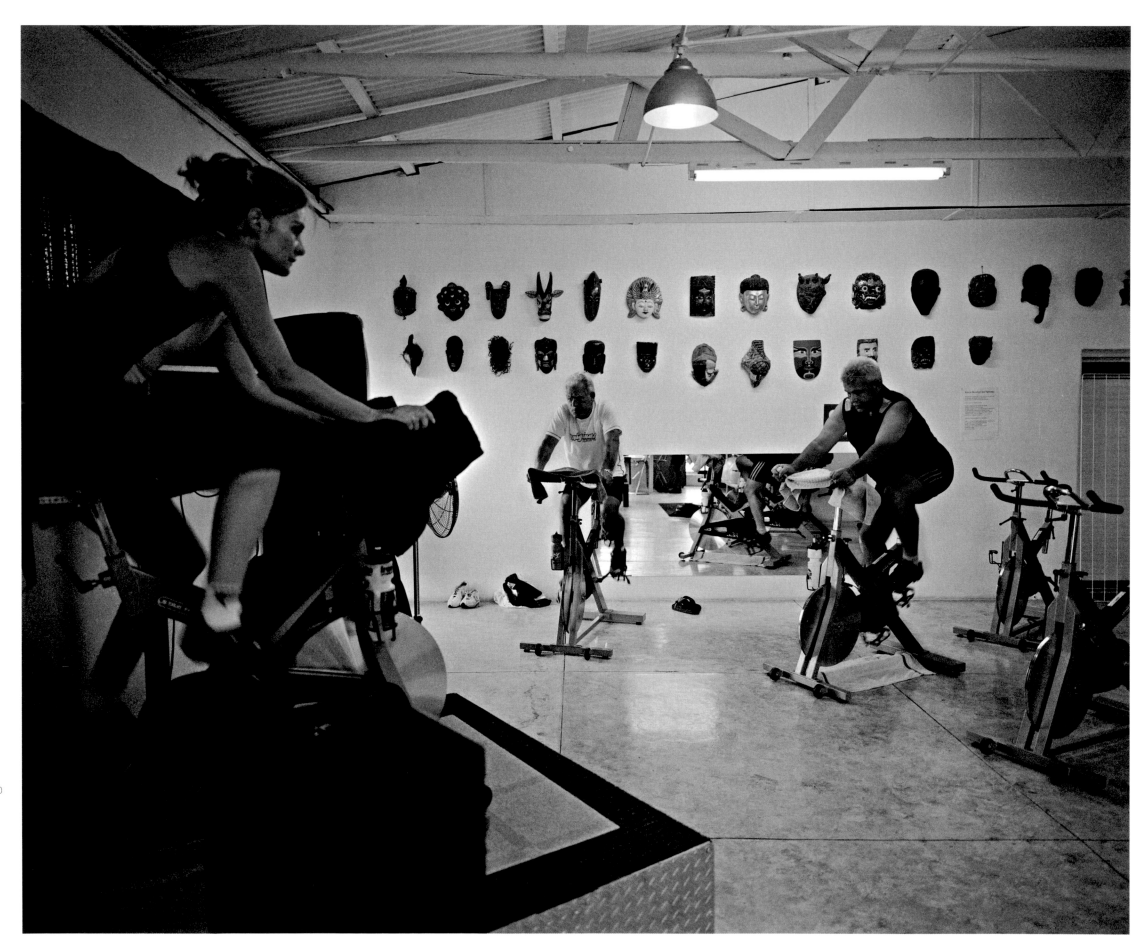

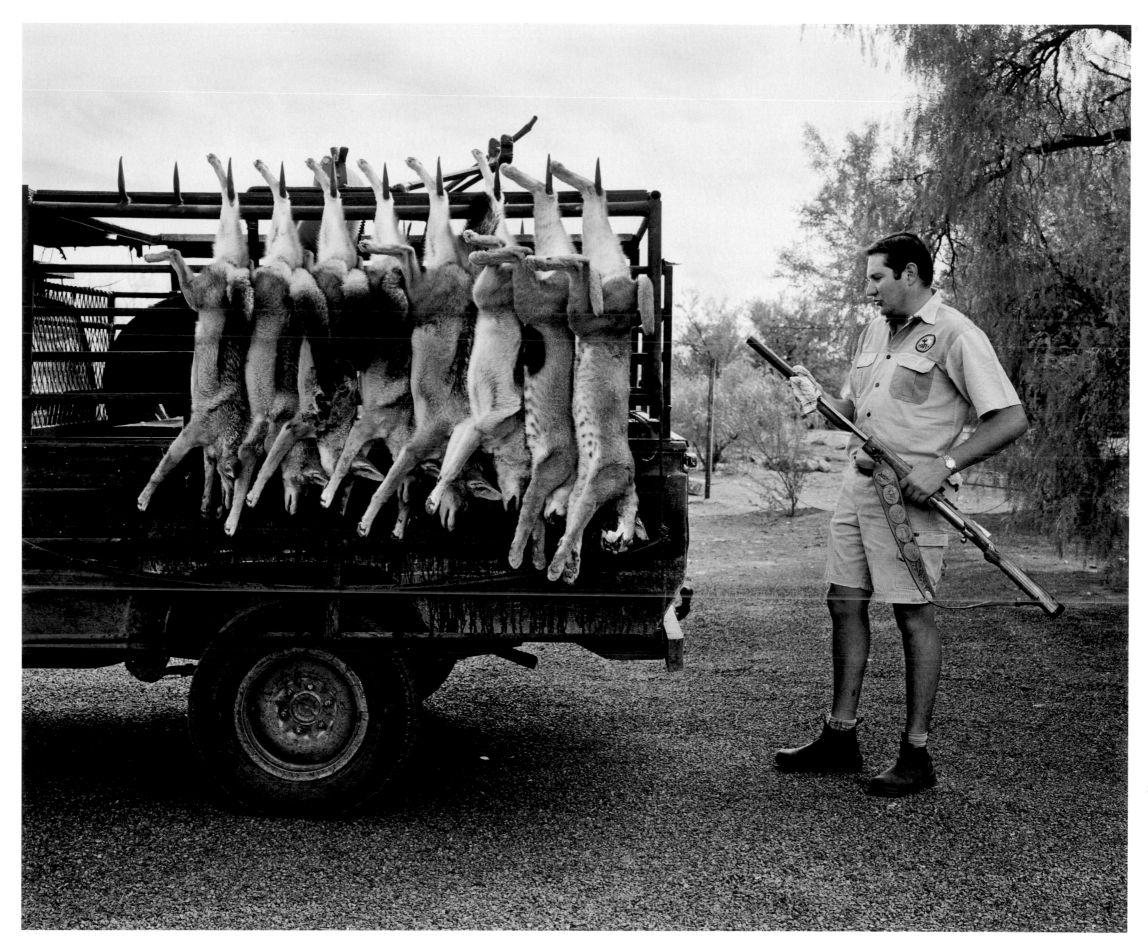

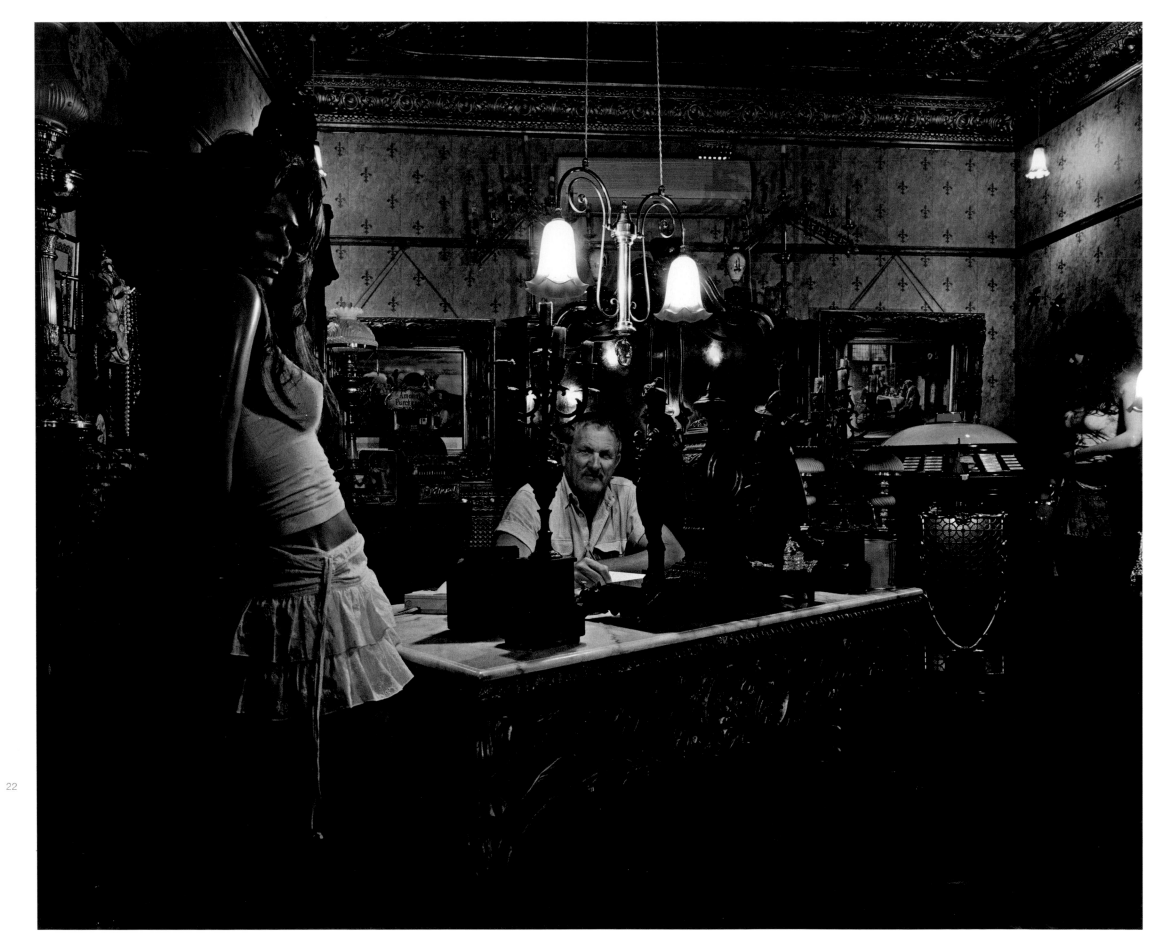

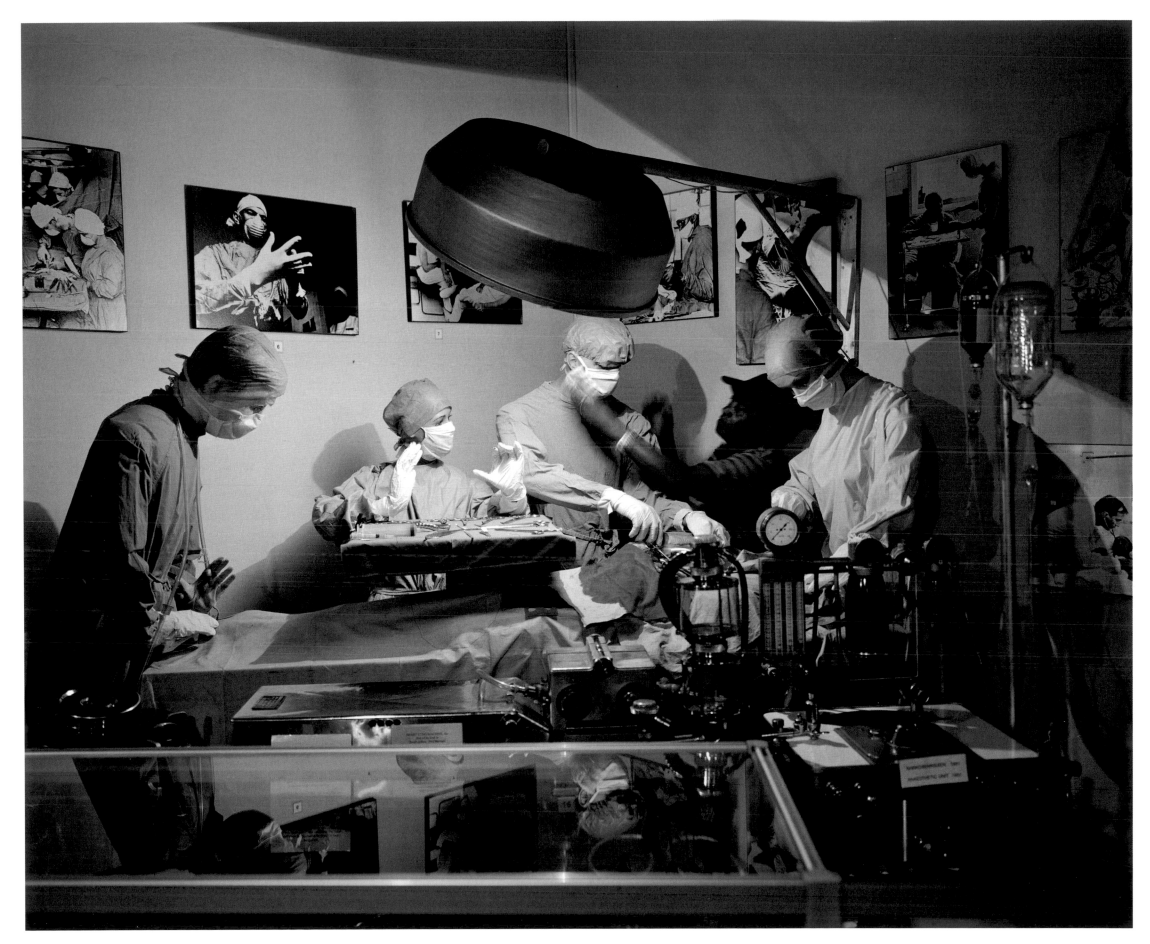

Page 22 **Mr Rossouw, Donkin Street, 2006** Page 23 Diorama, Chris Barnard Museum, 2008 Opposite Runner-Up, Miss Teen Beaufort West, 2007

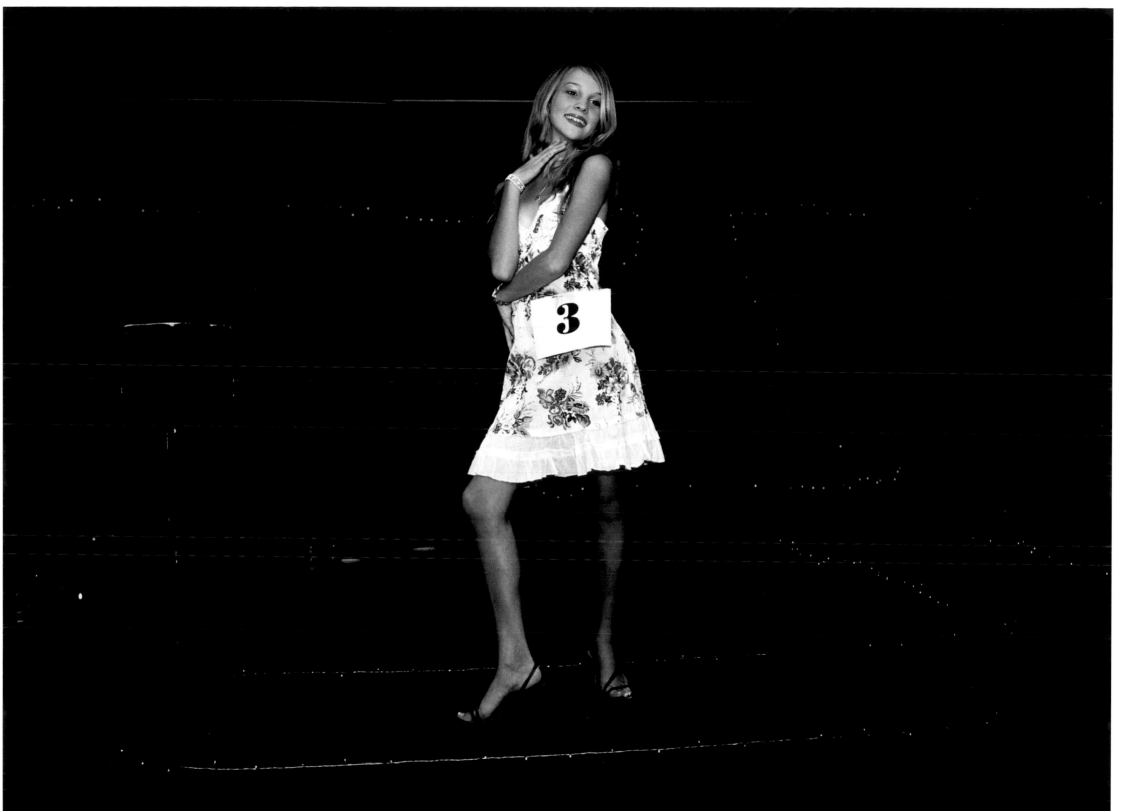

Traditional healer and patient, 2006

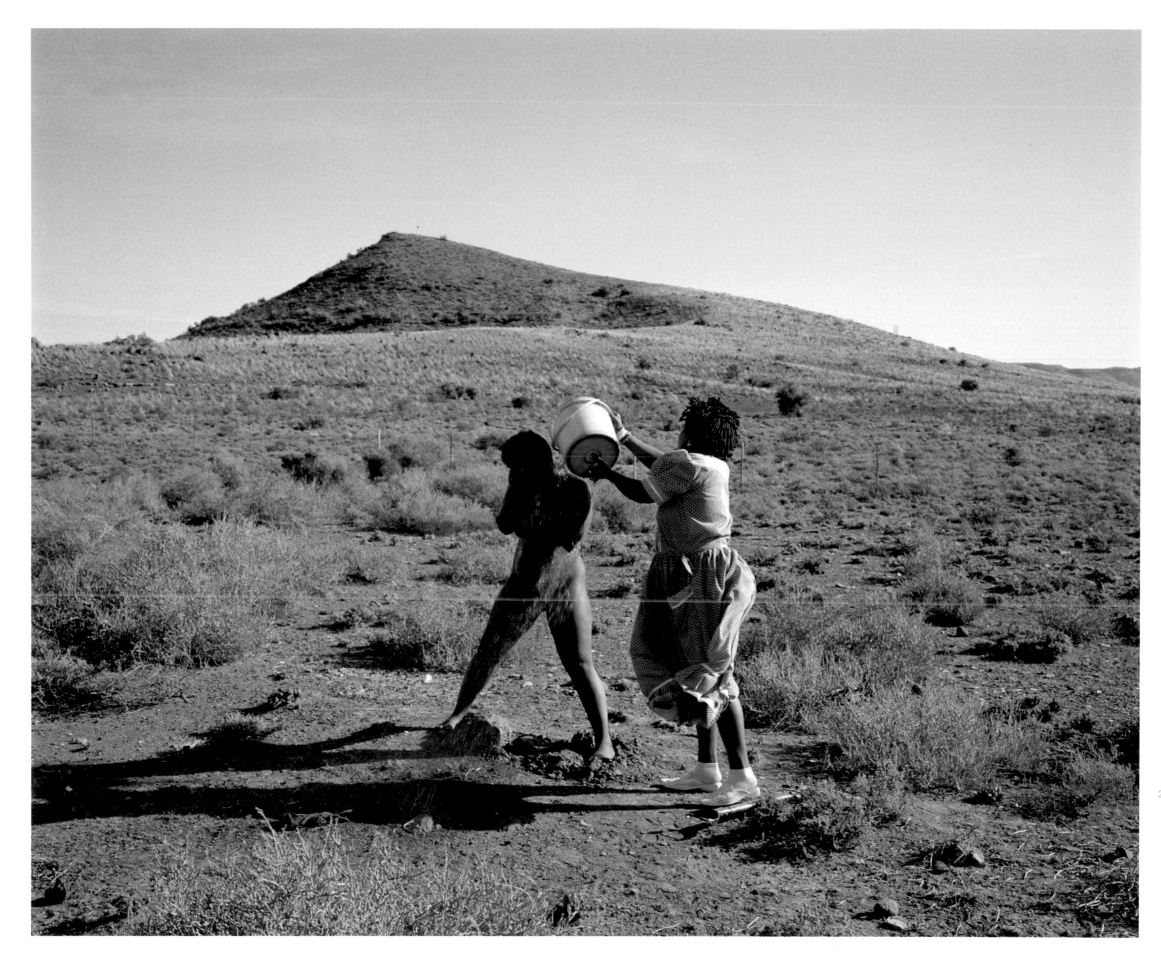

Opposite **Offering to the ancestors, Kwa Mandlankosi, 2006** │ Page 30 **At the liquor store, Donkin Street, 2006** │ Page 31 **At the butcher's, Donkin Street, 2006**

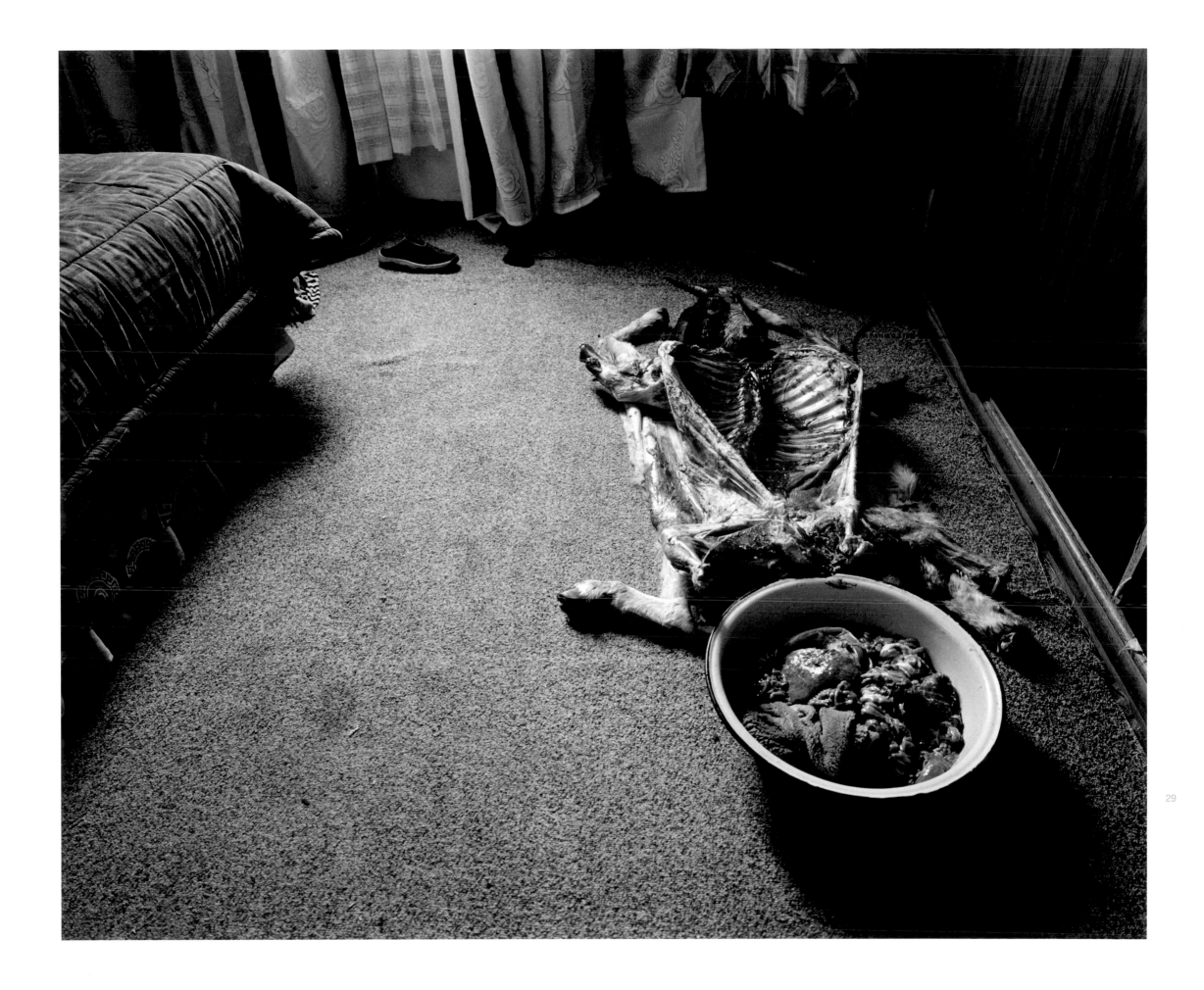

29

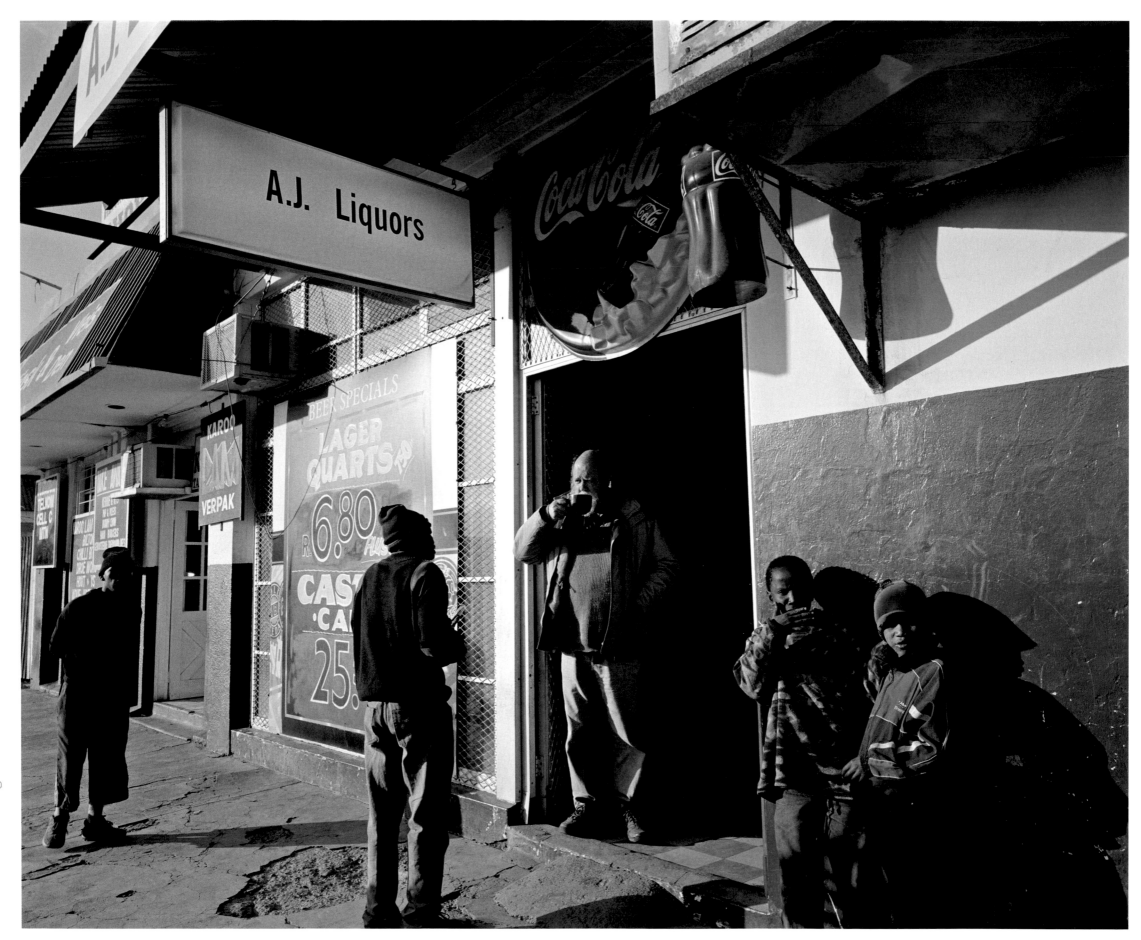

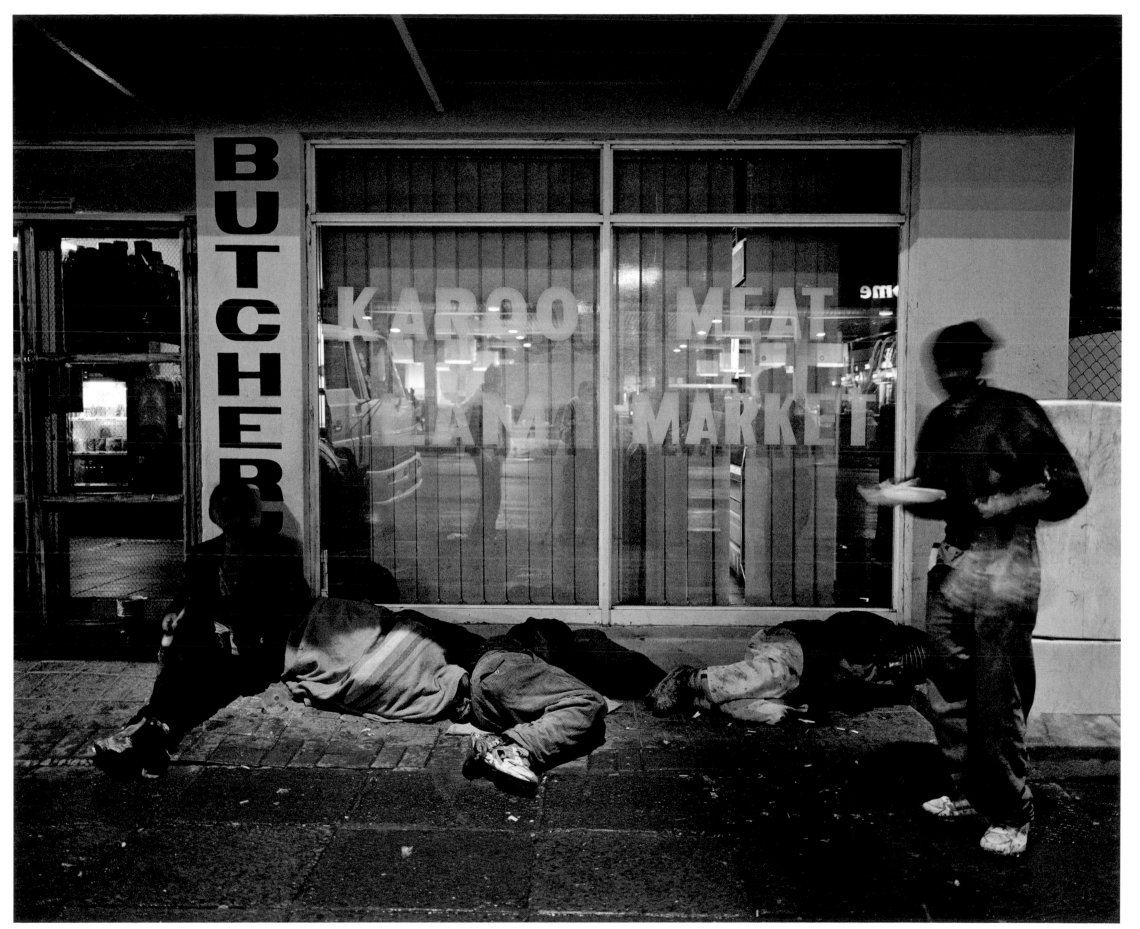

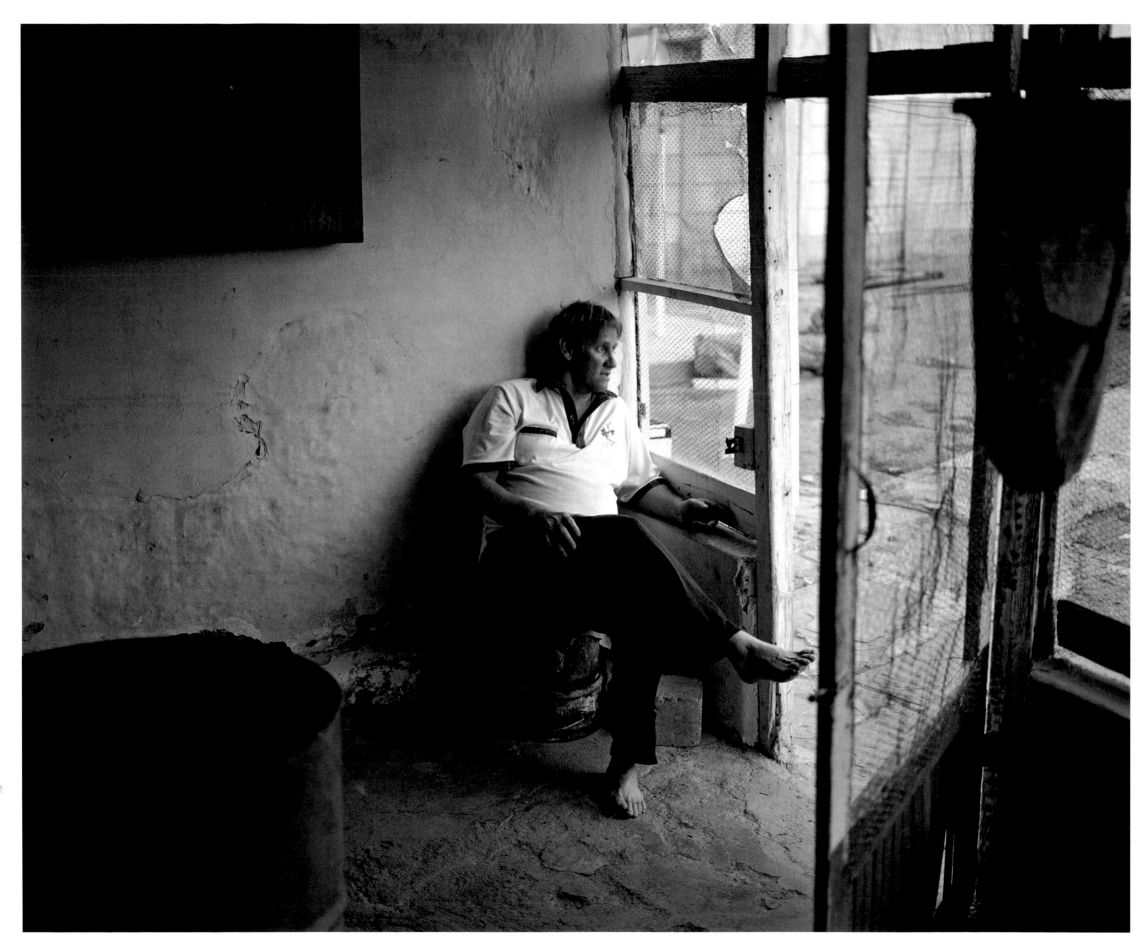

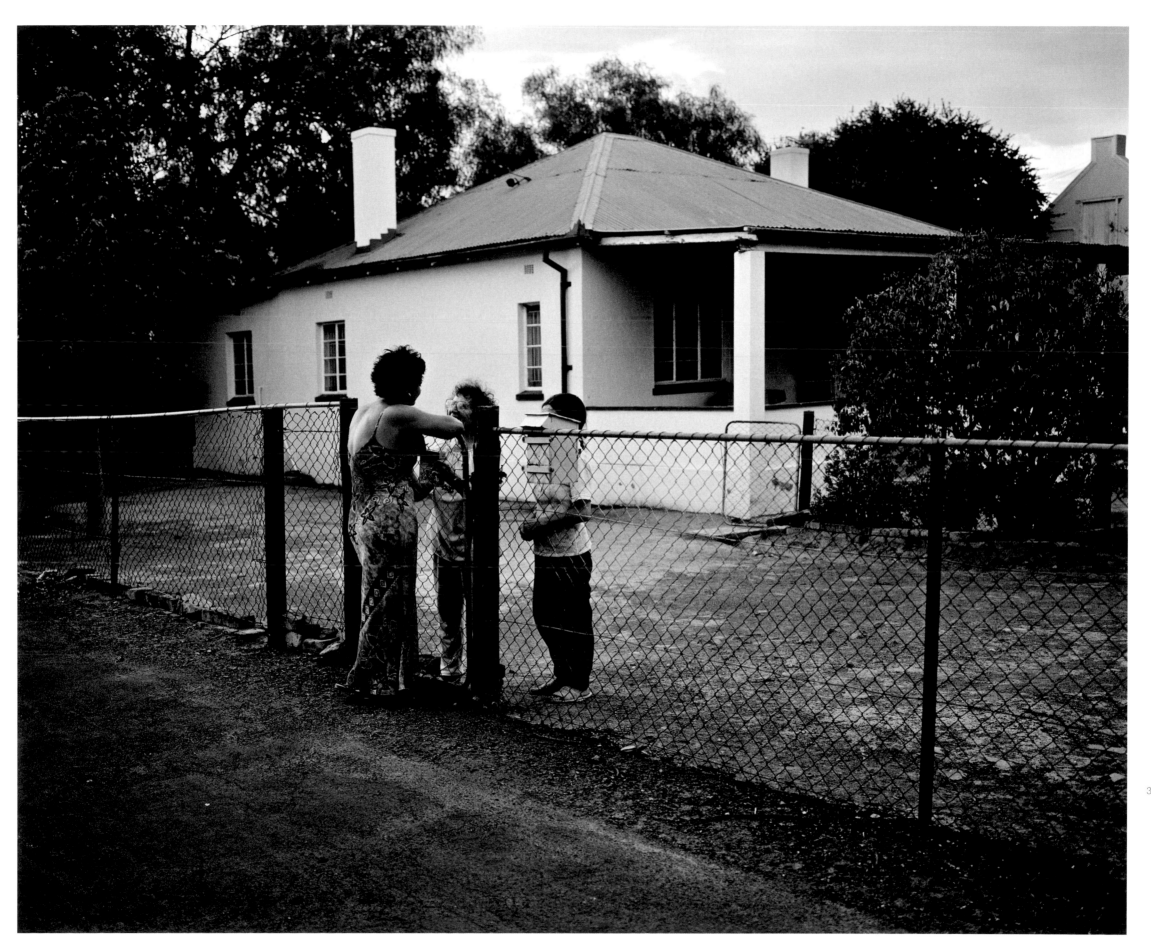

34

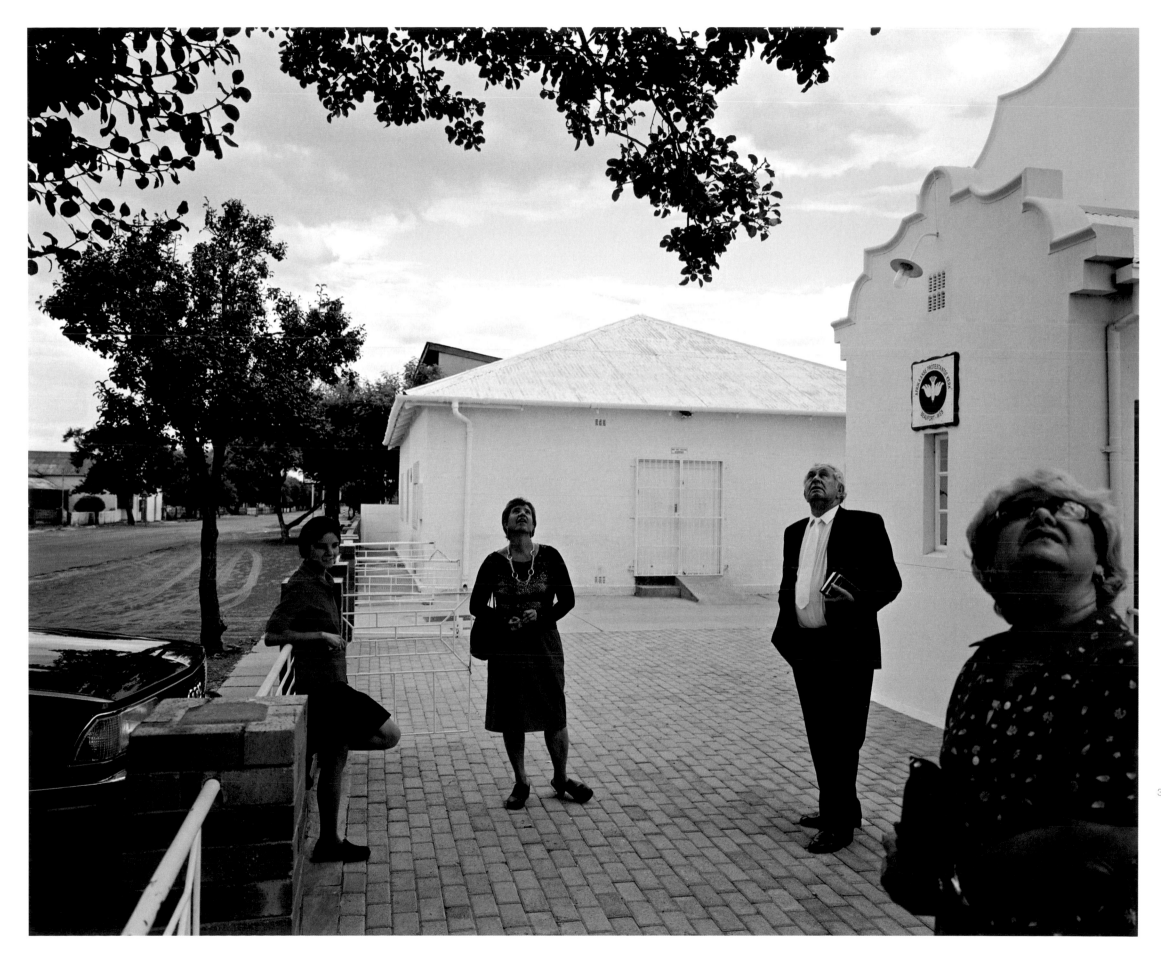

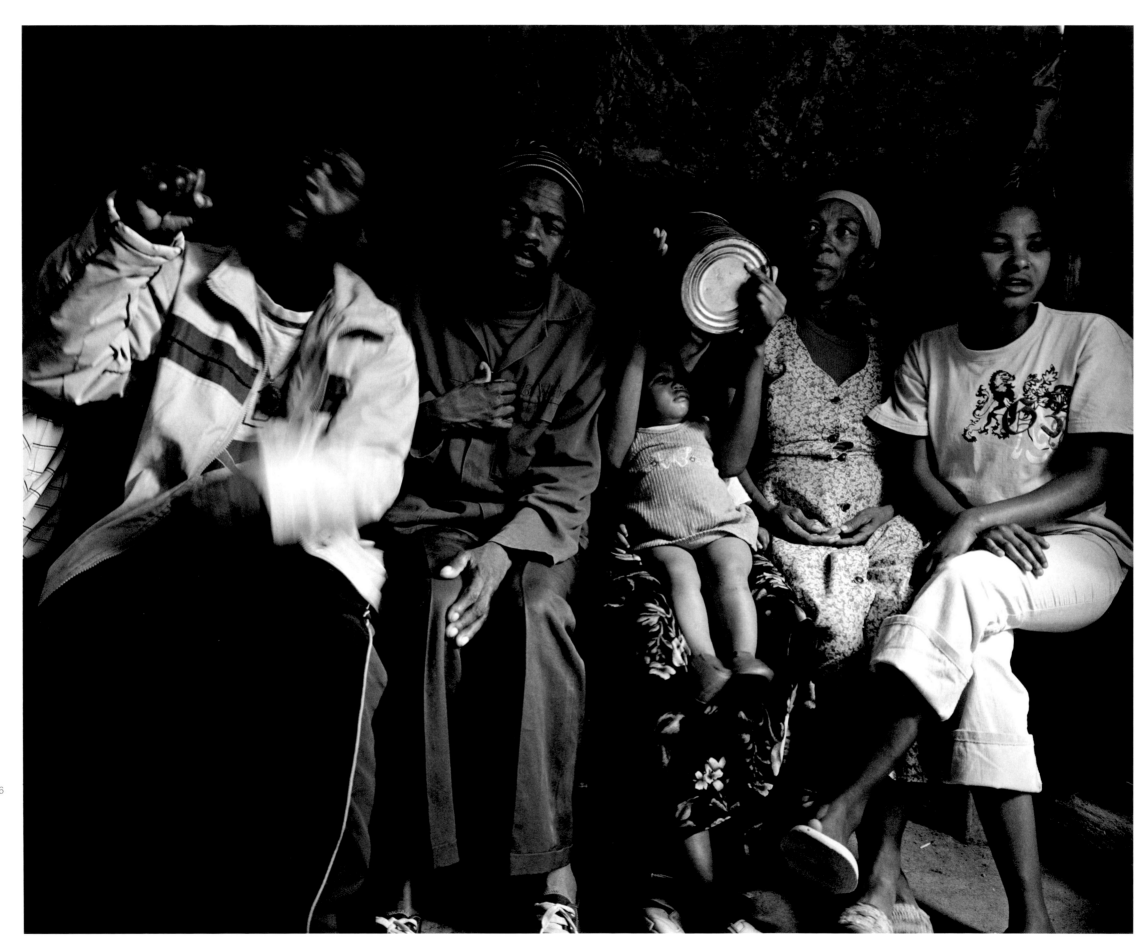

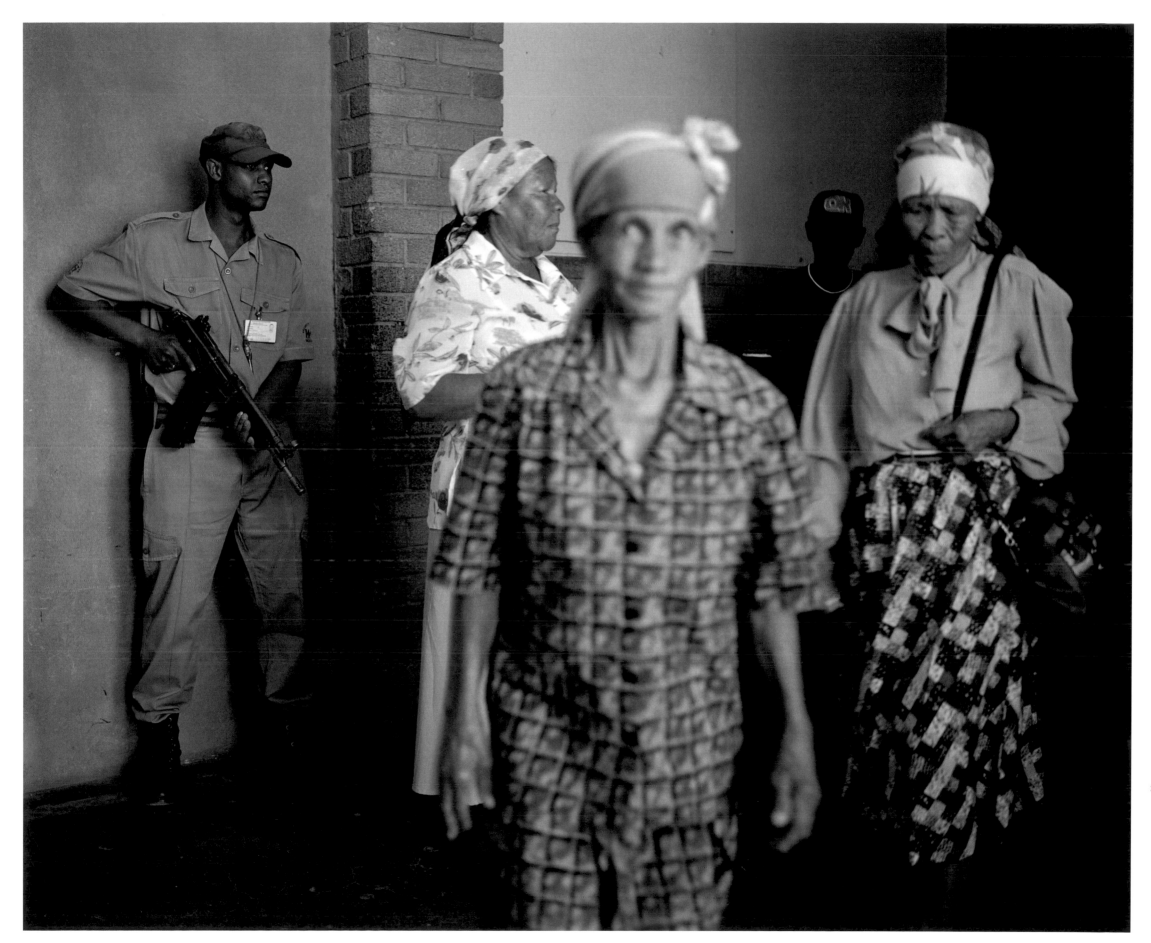

Page 36 **Pine house, 2006** | Page 37 **Allpay, 2008** | Opposite **Poolhall, Toekomsrus, 2008**

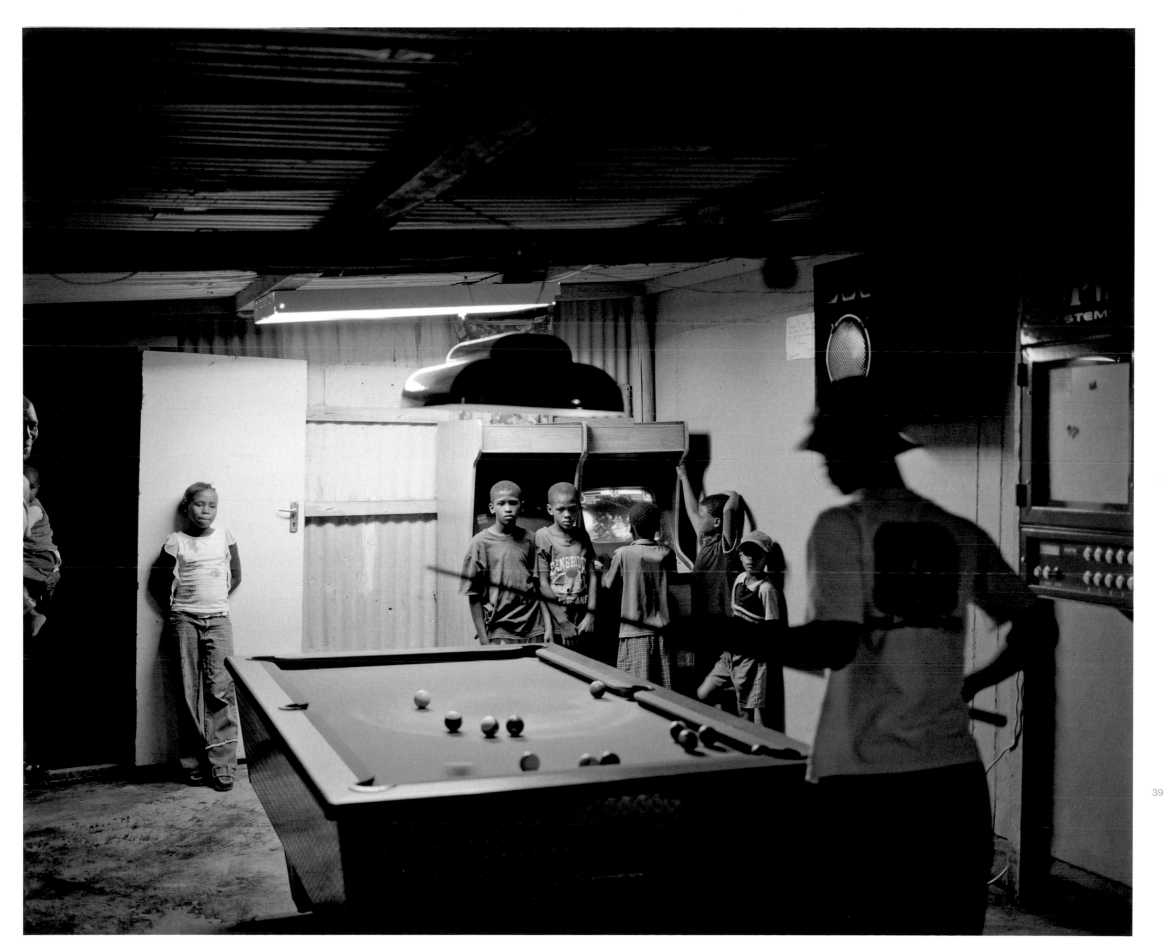

40 Fuck Me, Toekomsrus, 2007

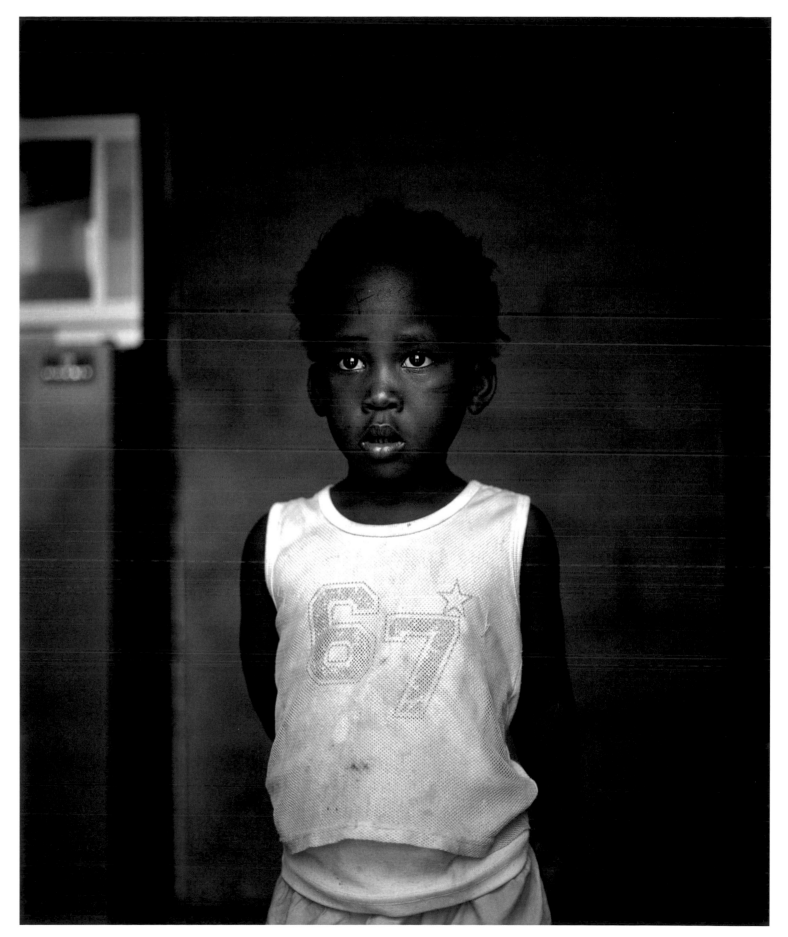

42 Hillside, 2008

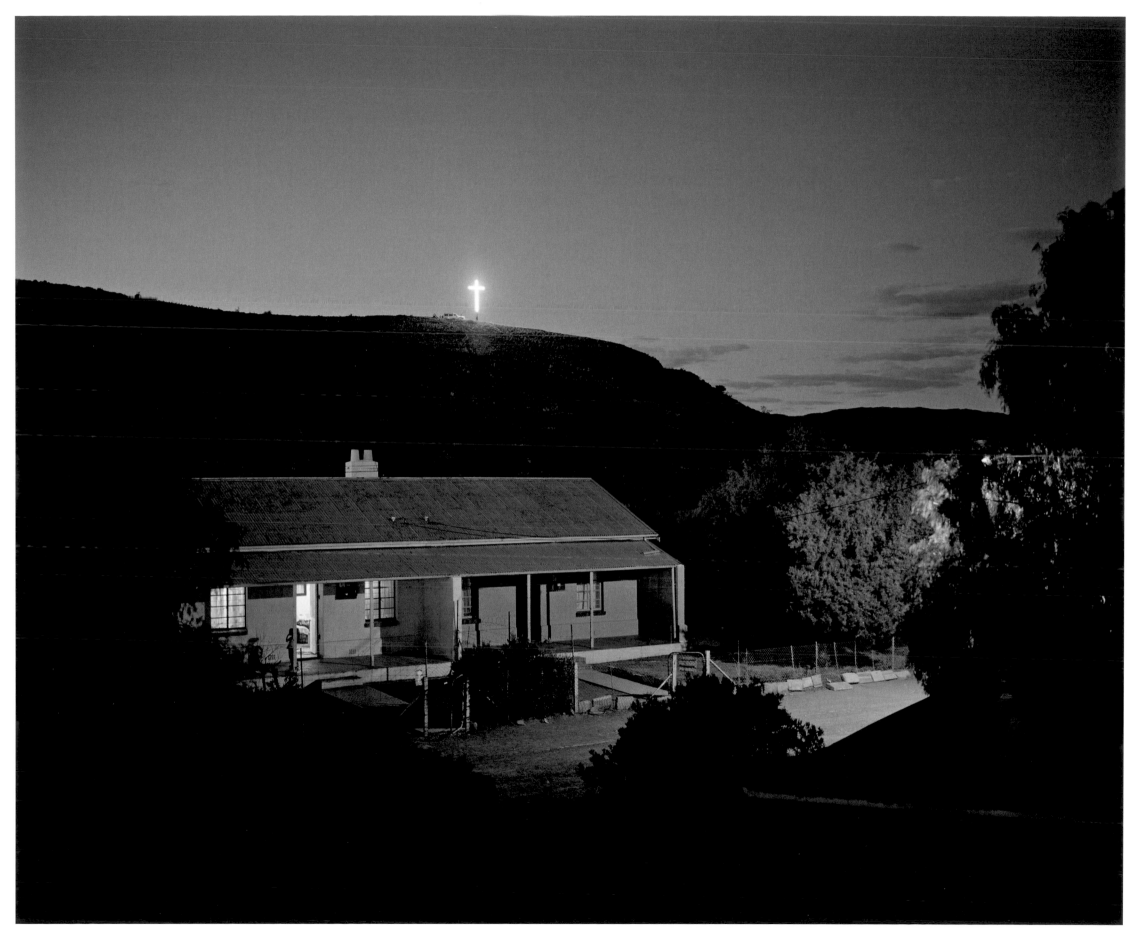

44 Joseph waits for X-Ray, Beaufort West Hospital, 2006

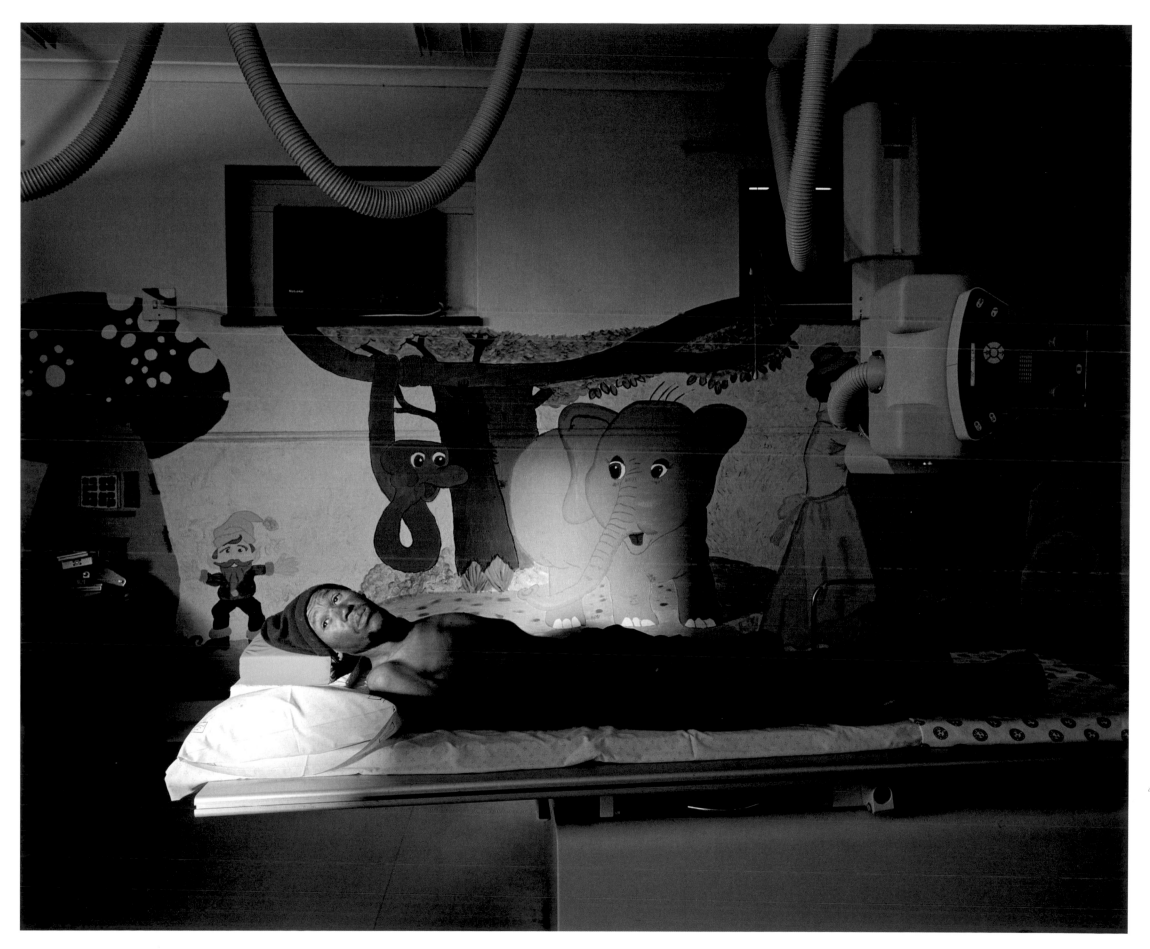

Opposite Bonita sings, Mallies household, Rustdene Township, 2006 | Page 48 Michelle, Mallies household, Rustdene Township, 2008 | Page 49 The Mallies family, Rustdene Township, 2006

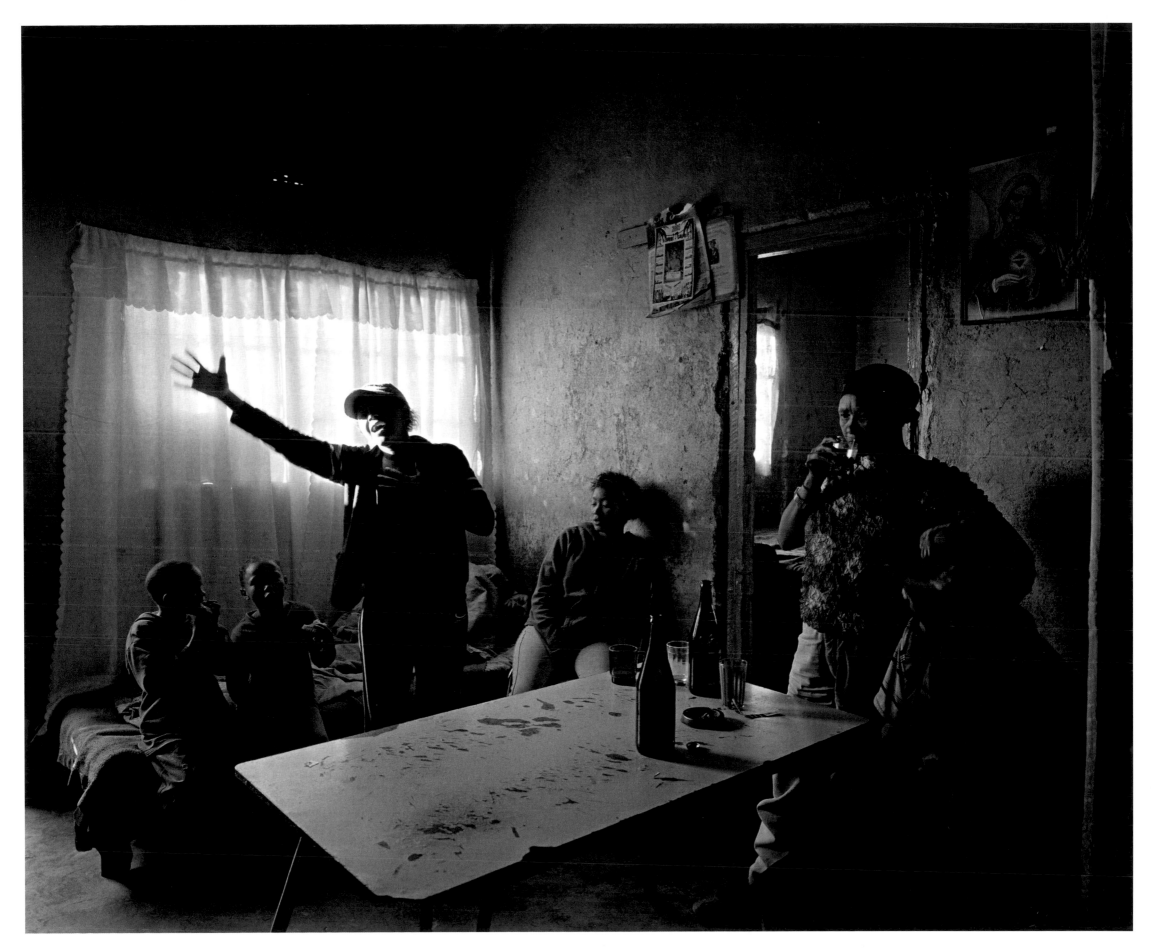

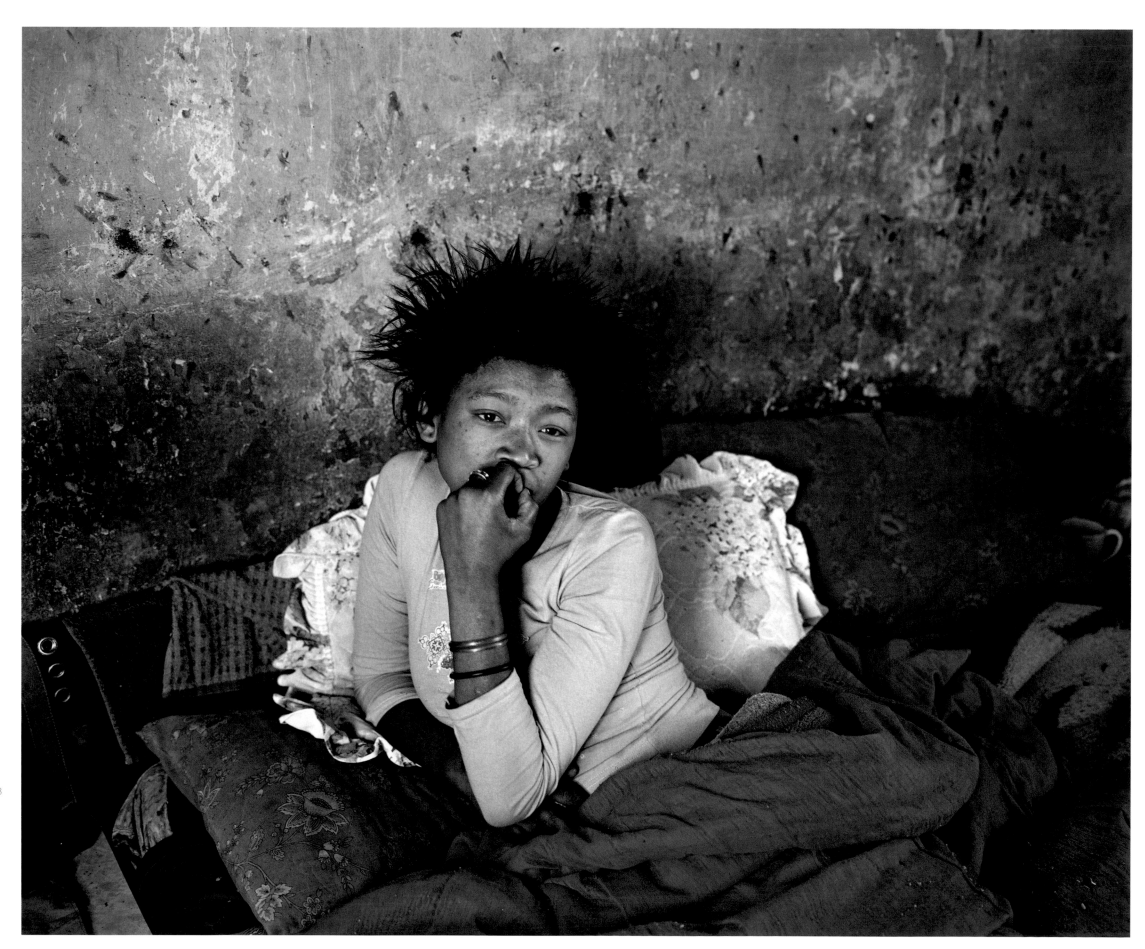

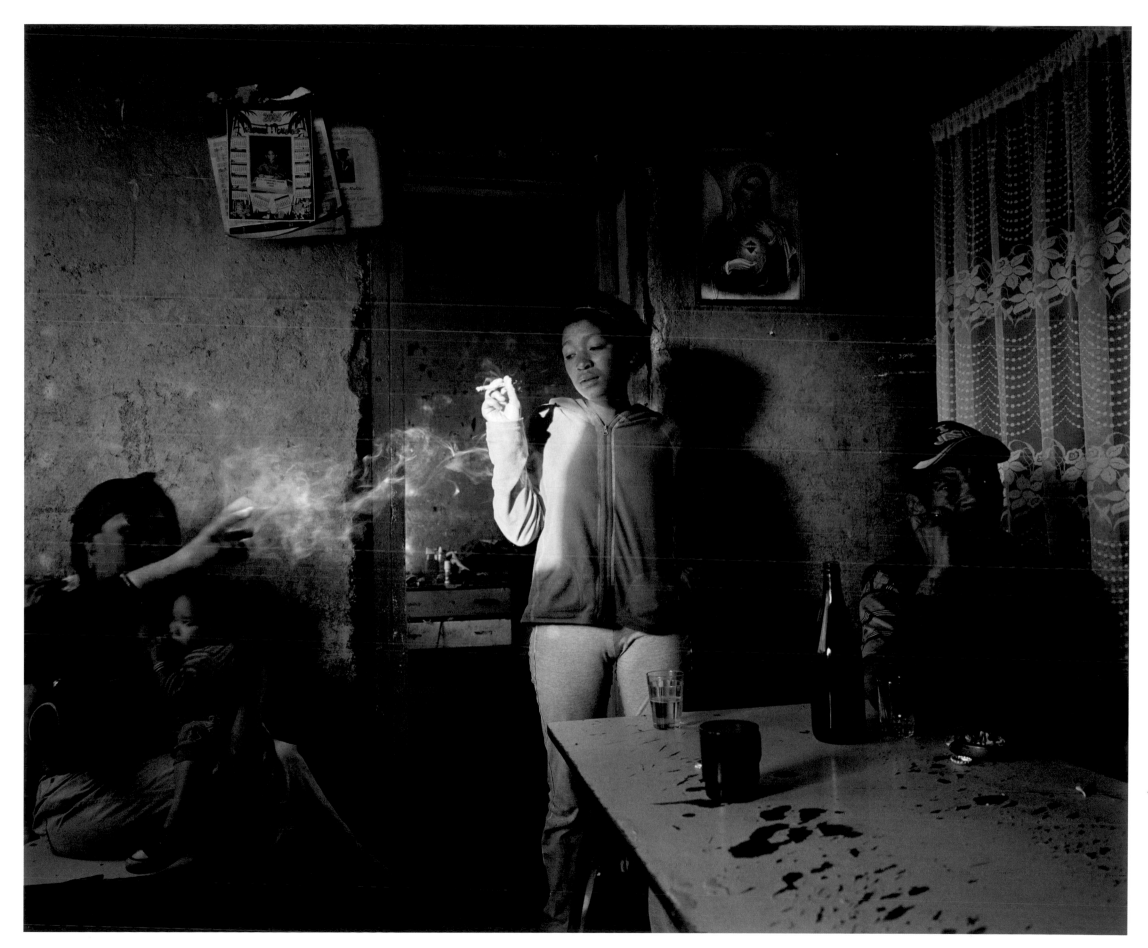

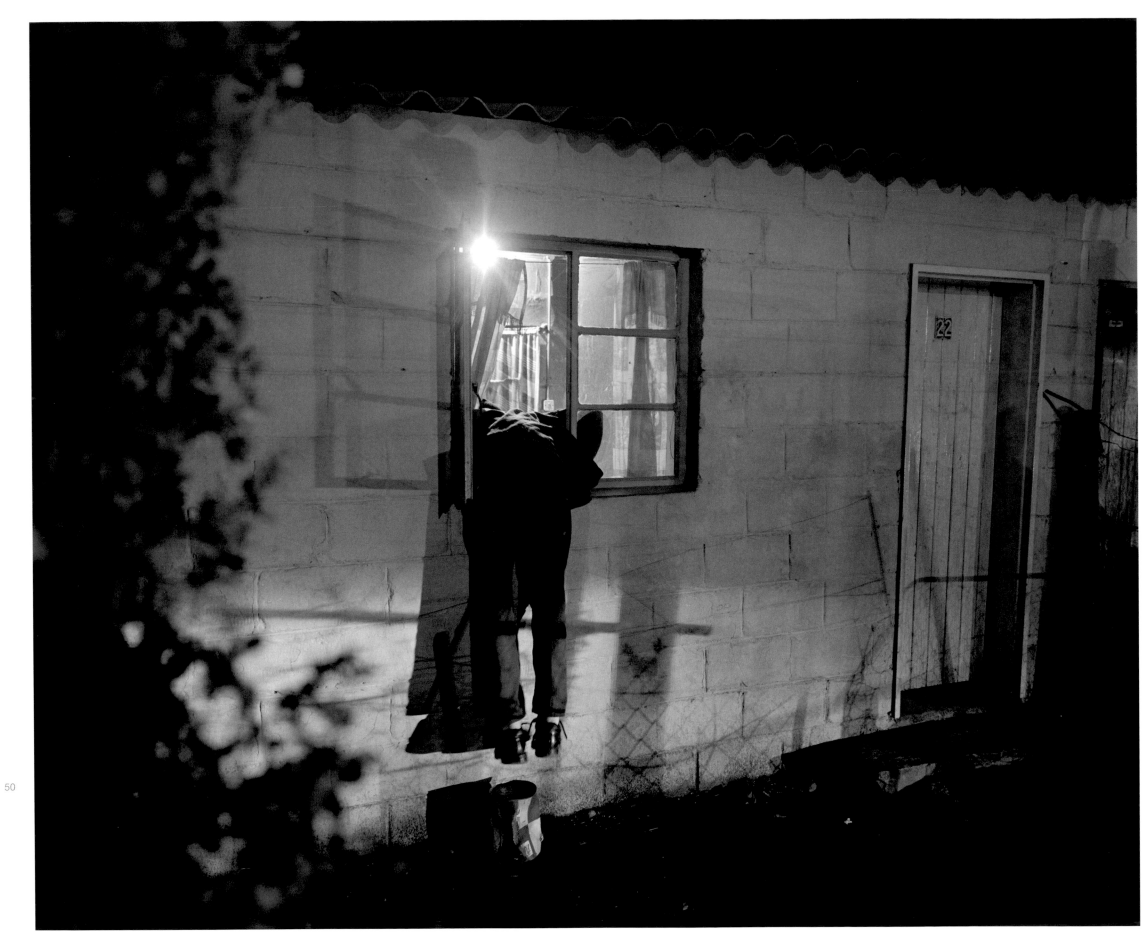

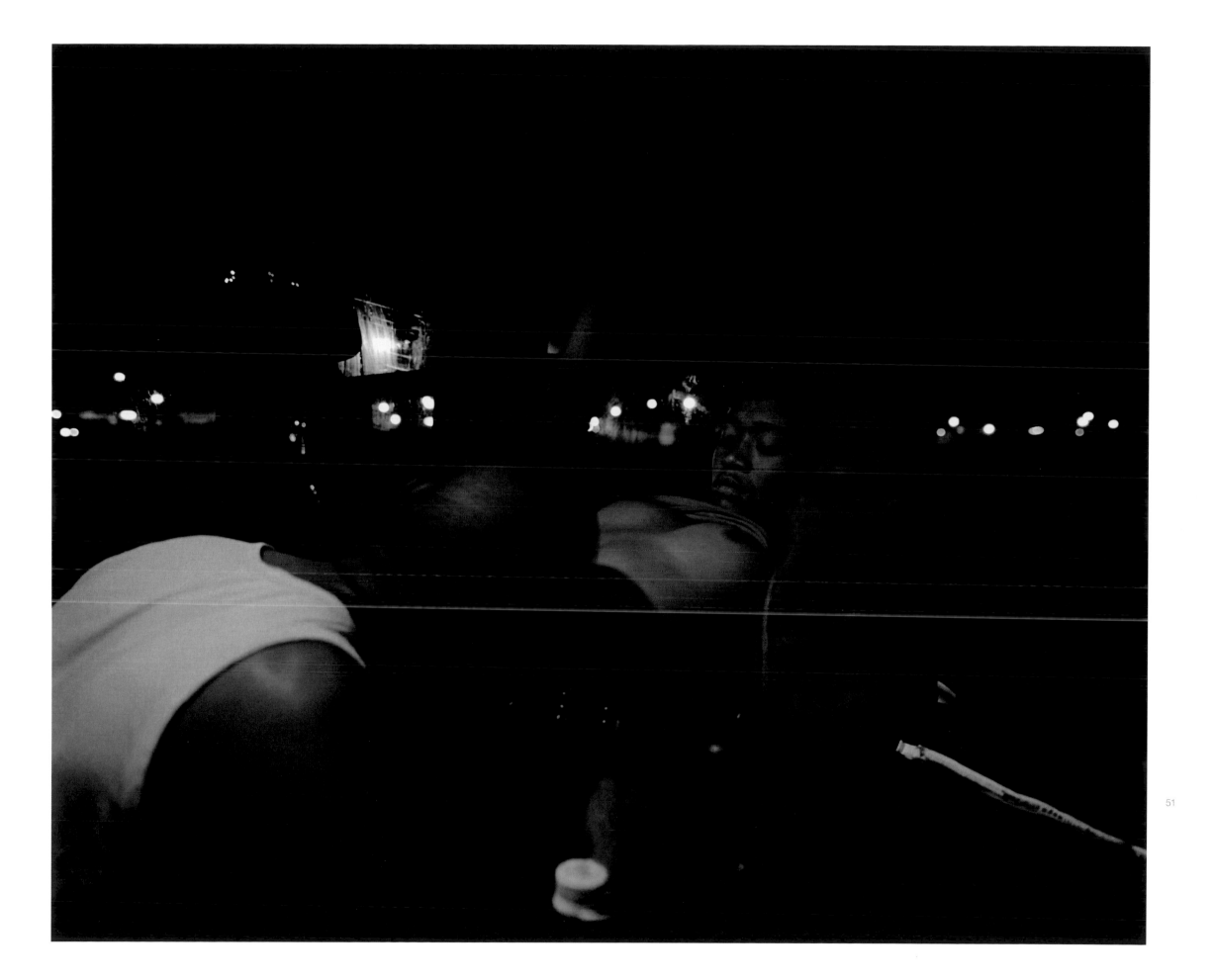

Page 50 **Break-in, Rustdene Township, 2006** | Page 51 **Michelle in the cab of a truck, 2006** | Opposite **Injured man, Plakkerskamp, 2008**

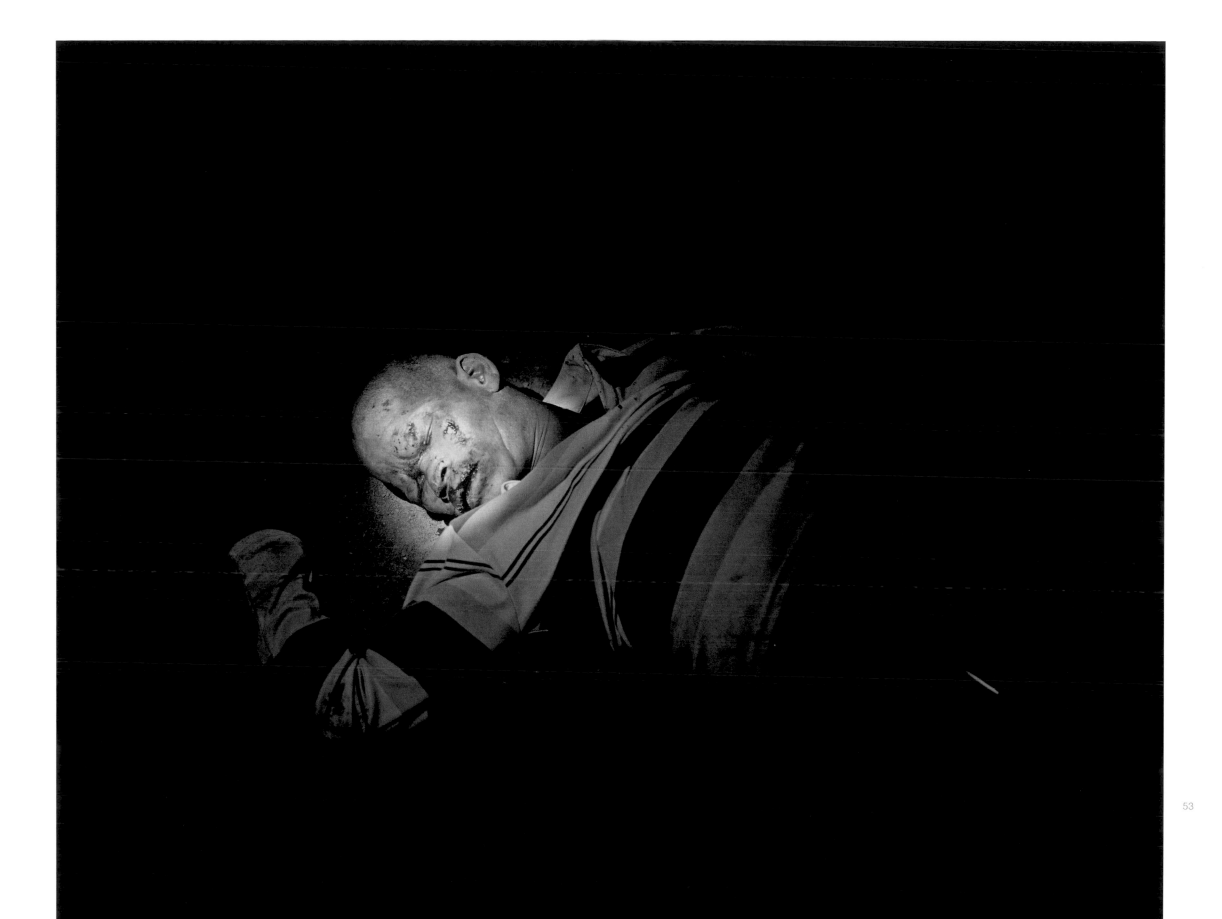

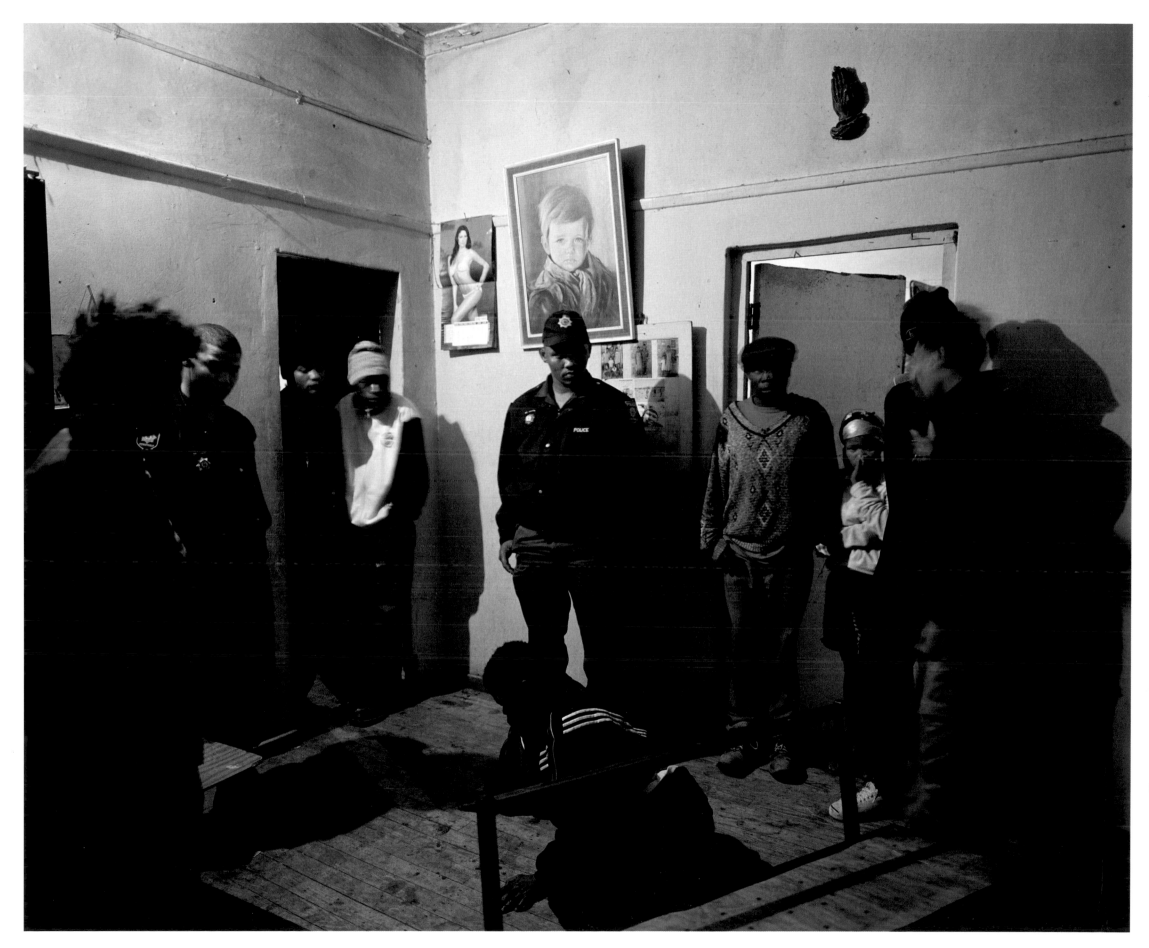

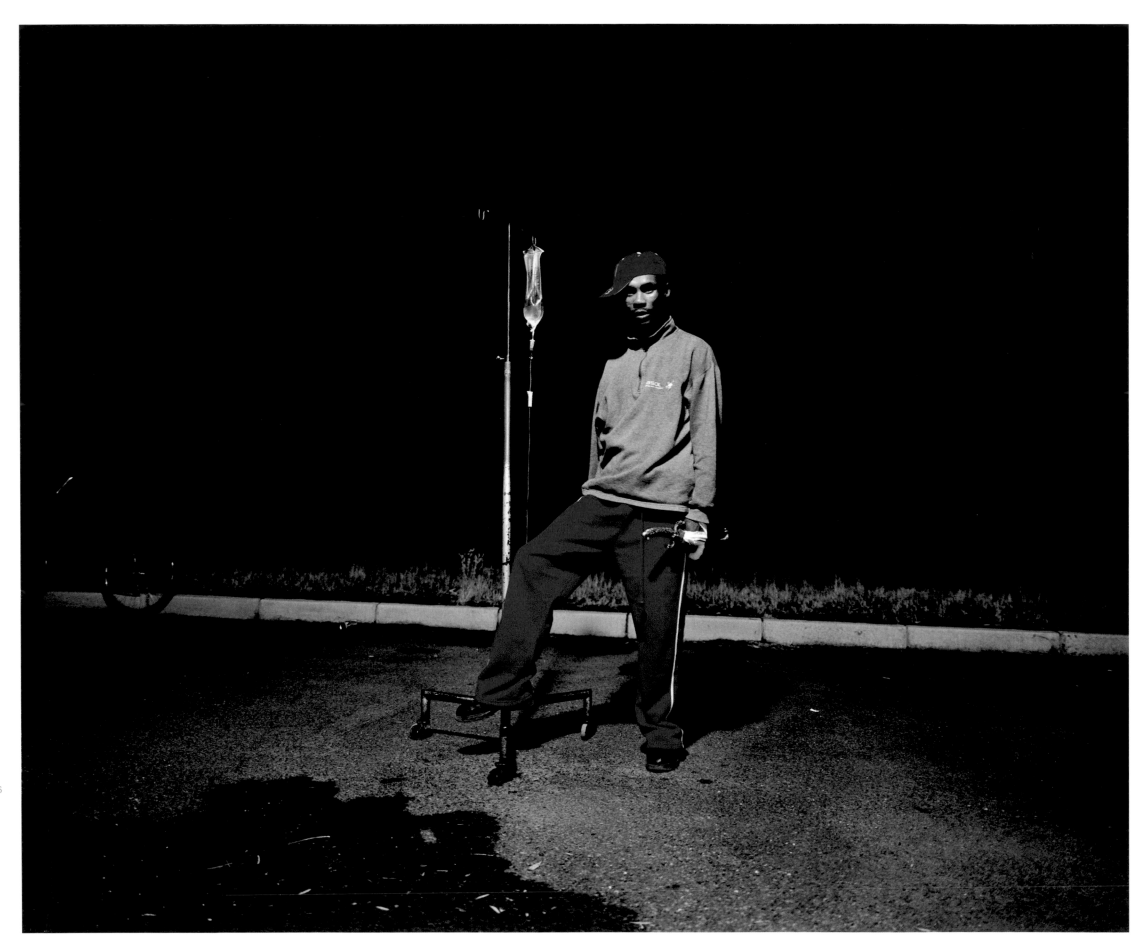

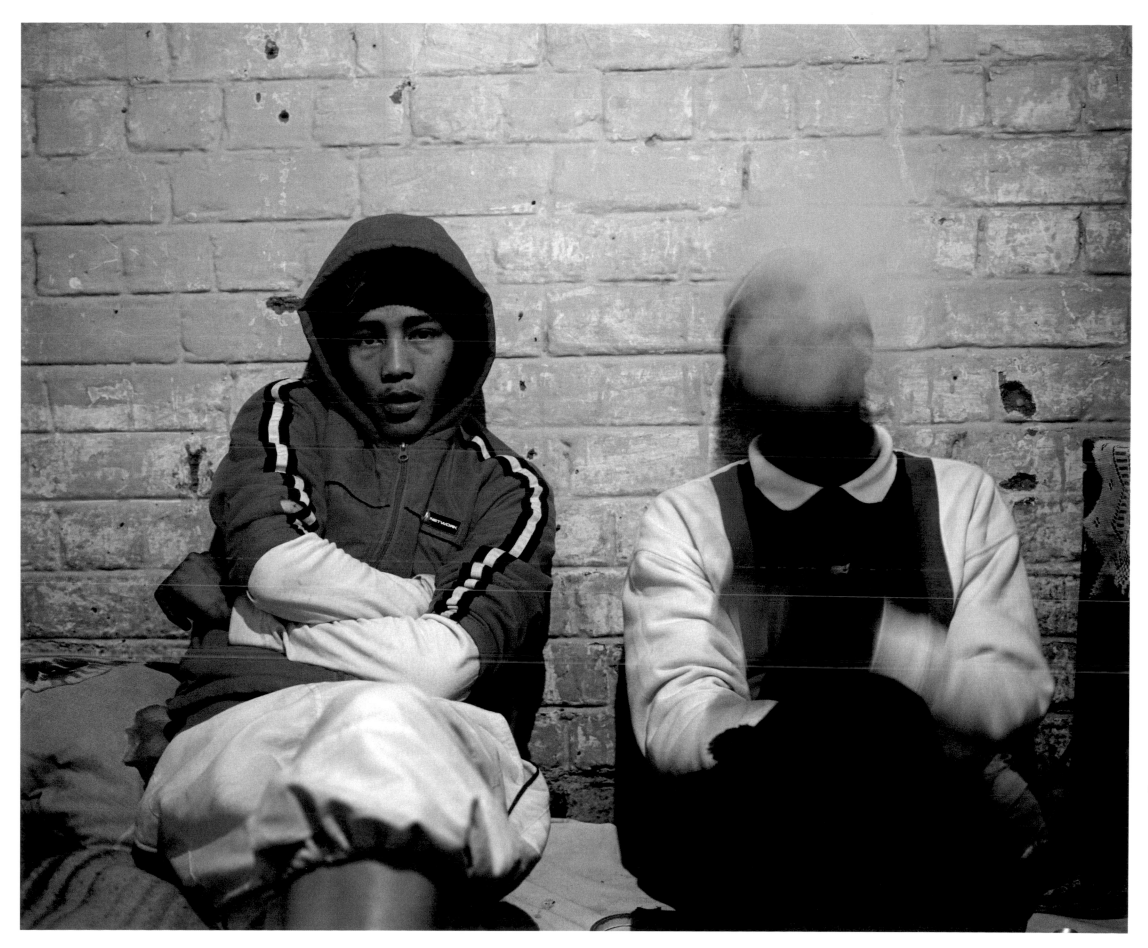

Police station, 2008

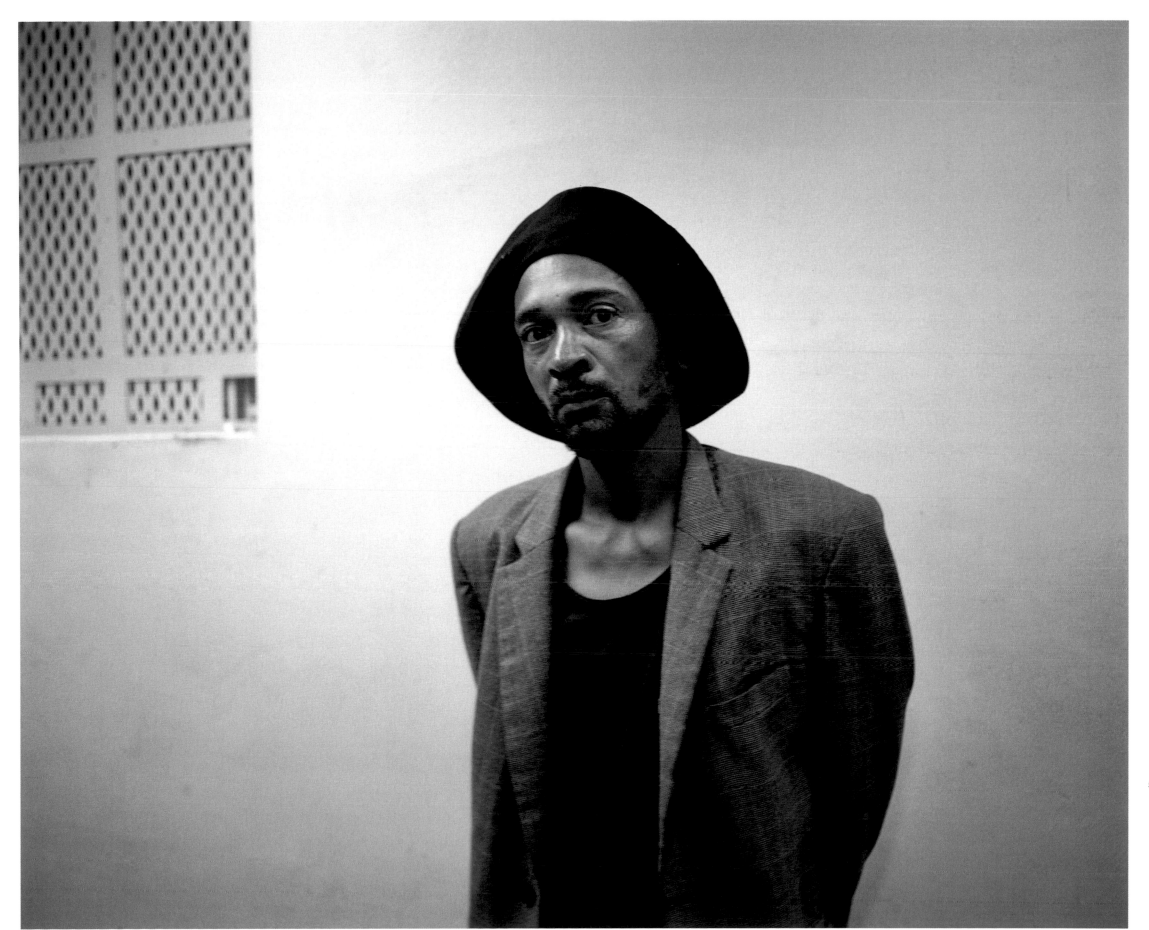

Police station, 2006

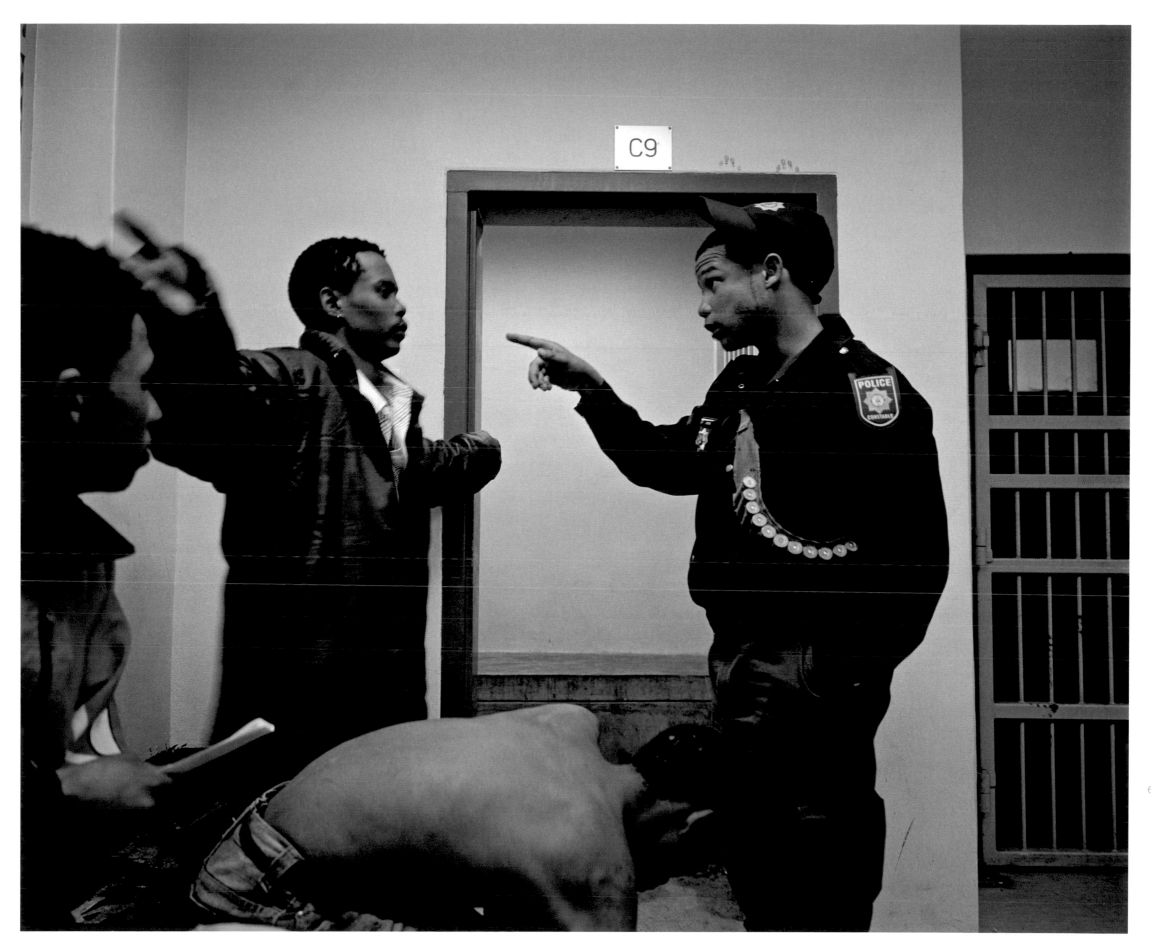

Police station, 2006

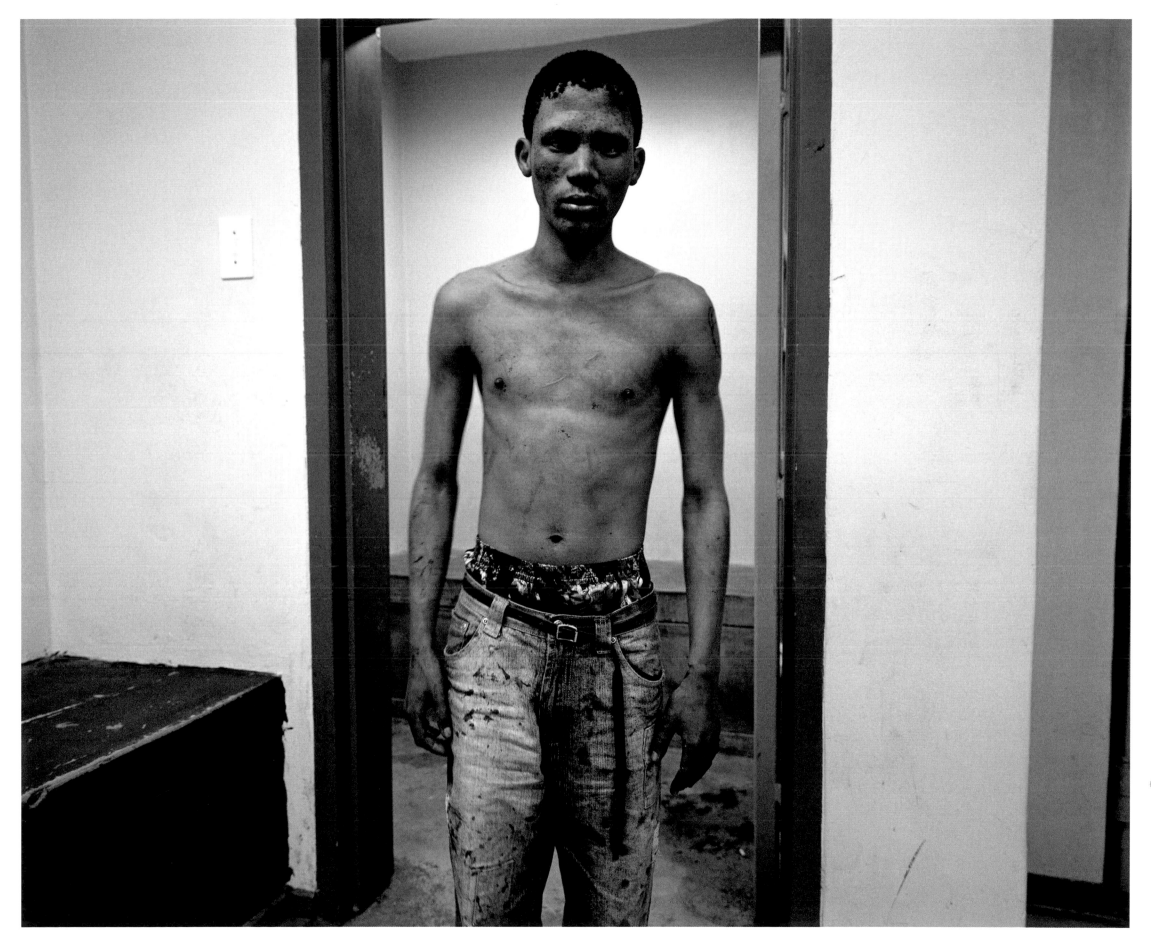

64 Police cells, 2006

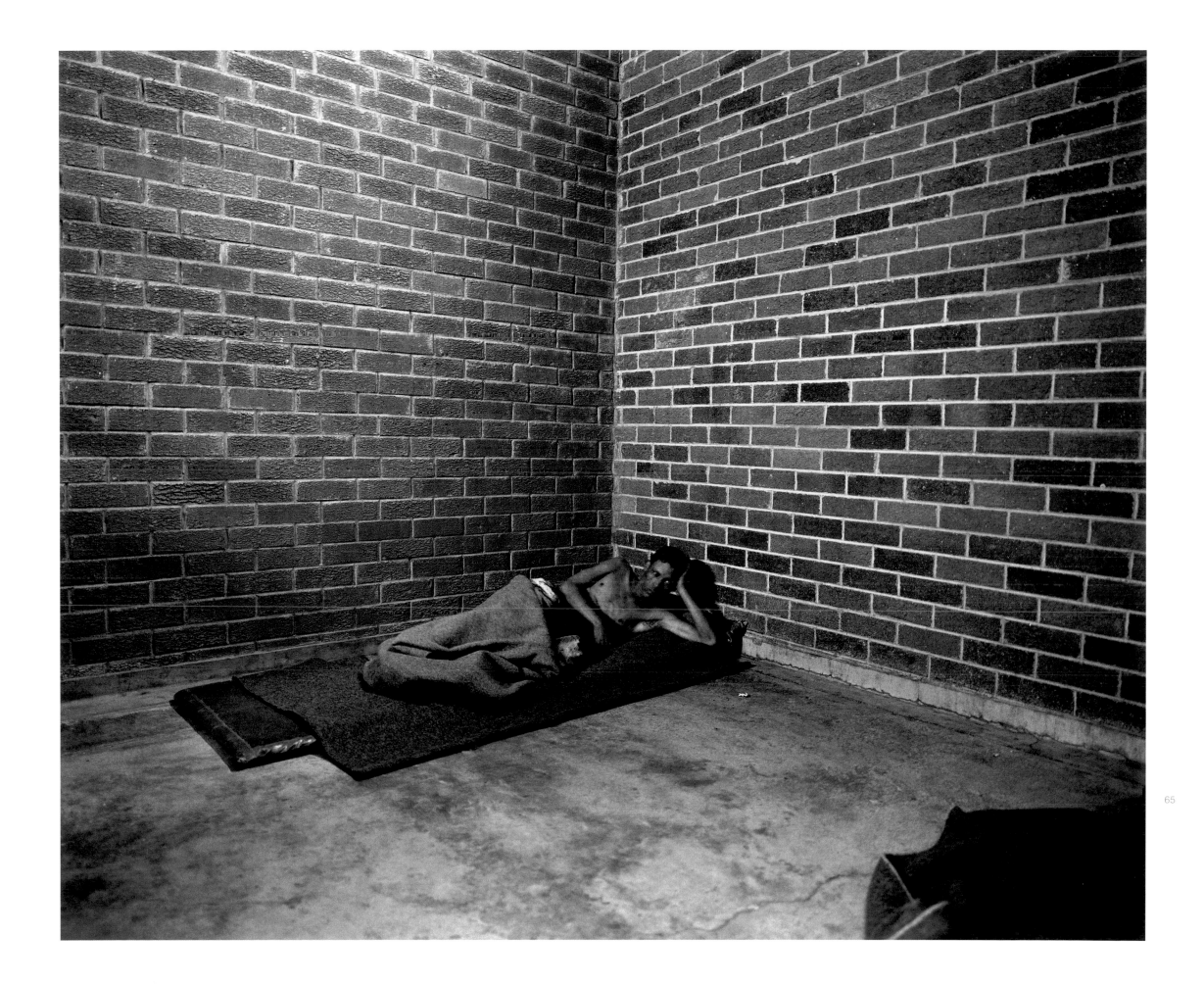

Tamatie, Beaufort West Prison, 2006

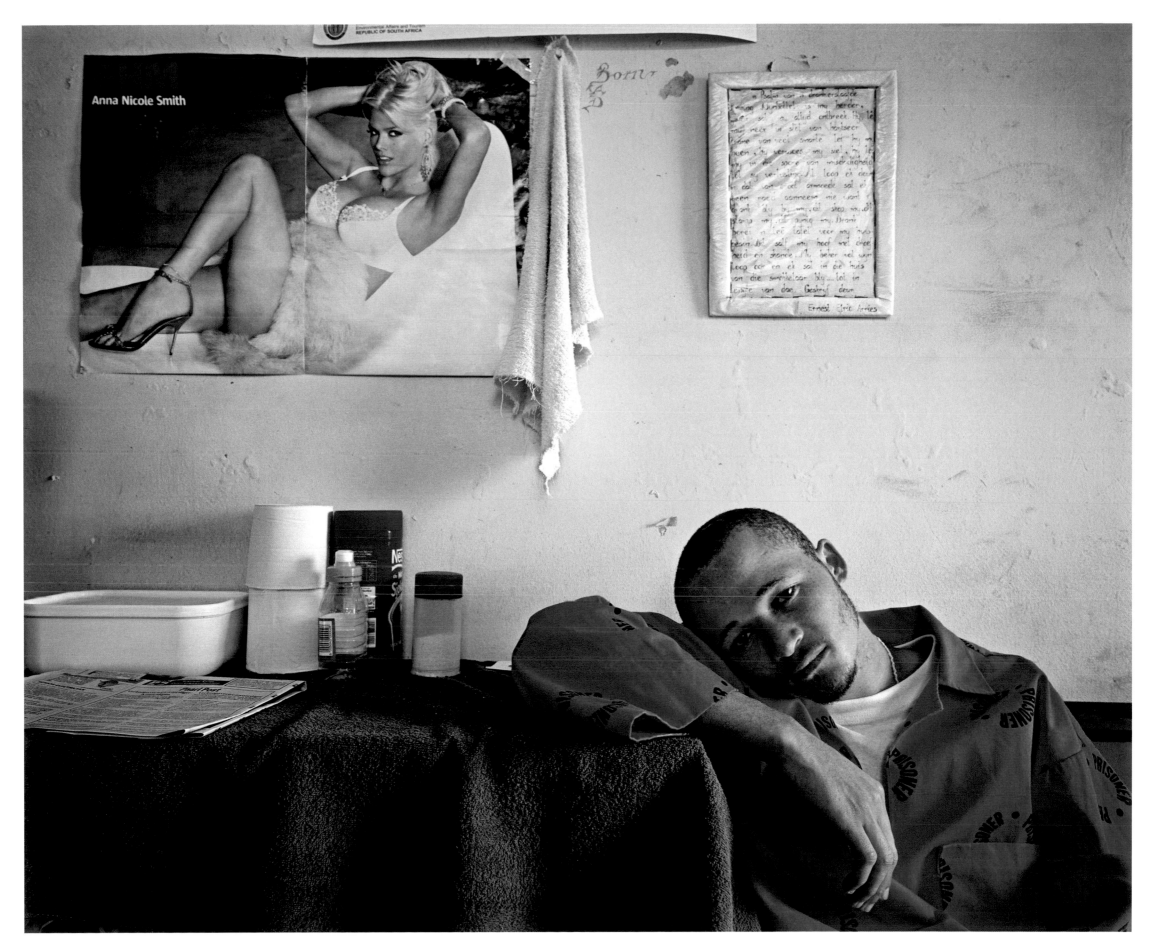

68 Shining the warder's shoes, Beaufort West Prison, 2006

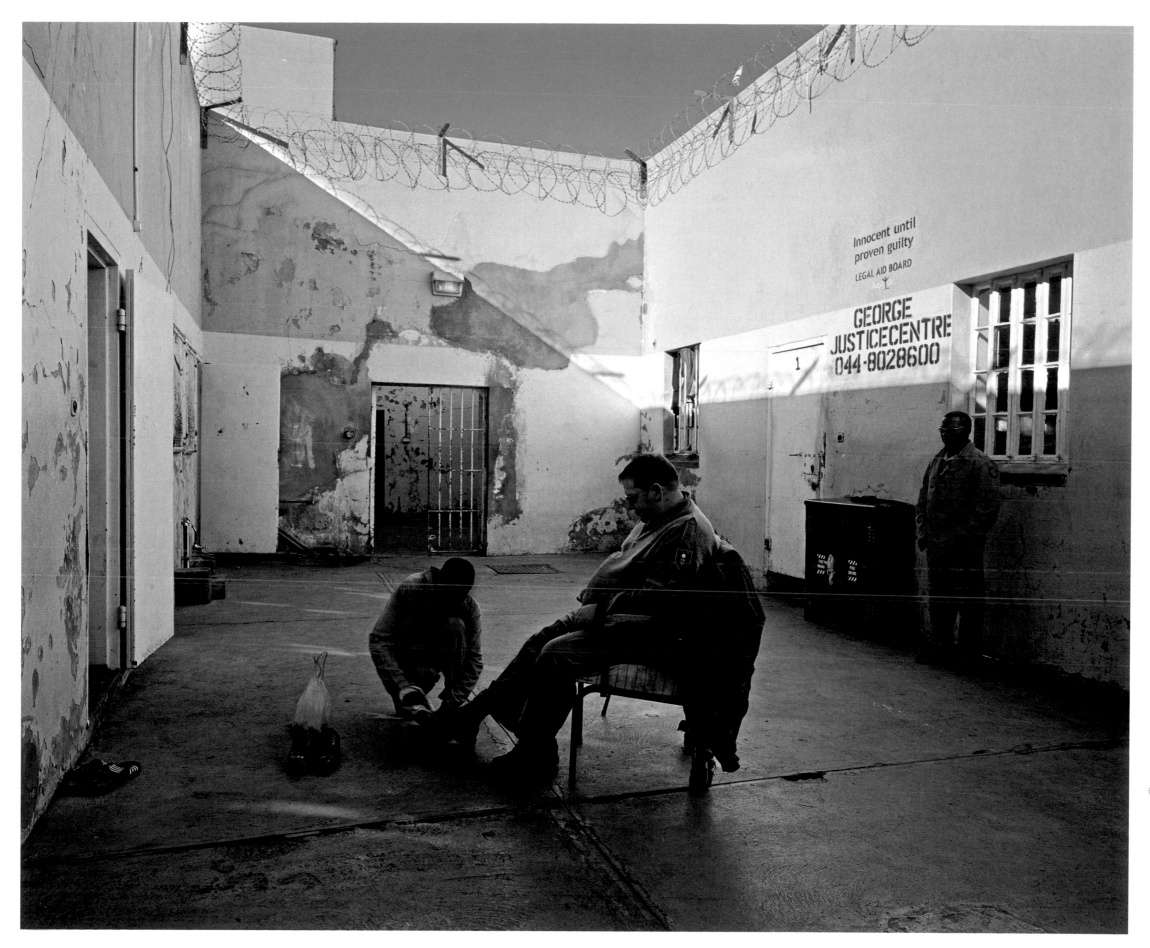

Innocent until
proven guilty

LEGAL AID BOARD

GEORGE
JUSTICECENTRE
044-8028600

1

70 Sunday service, Beaufort West Prison, 2006

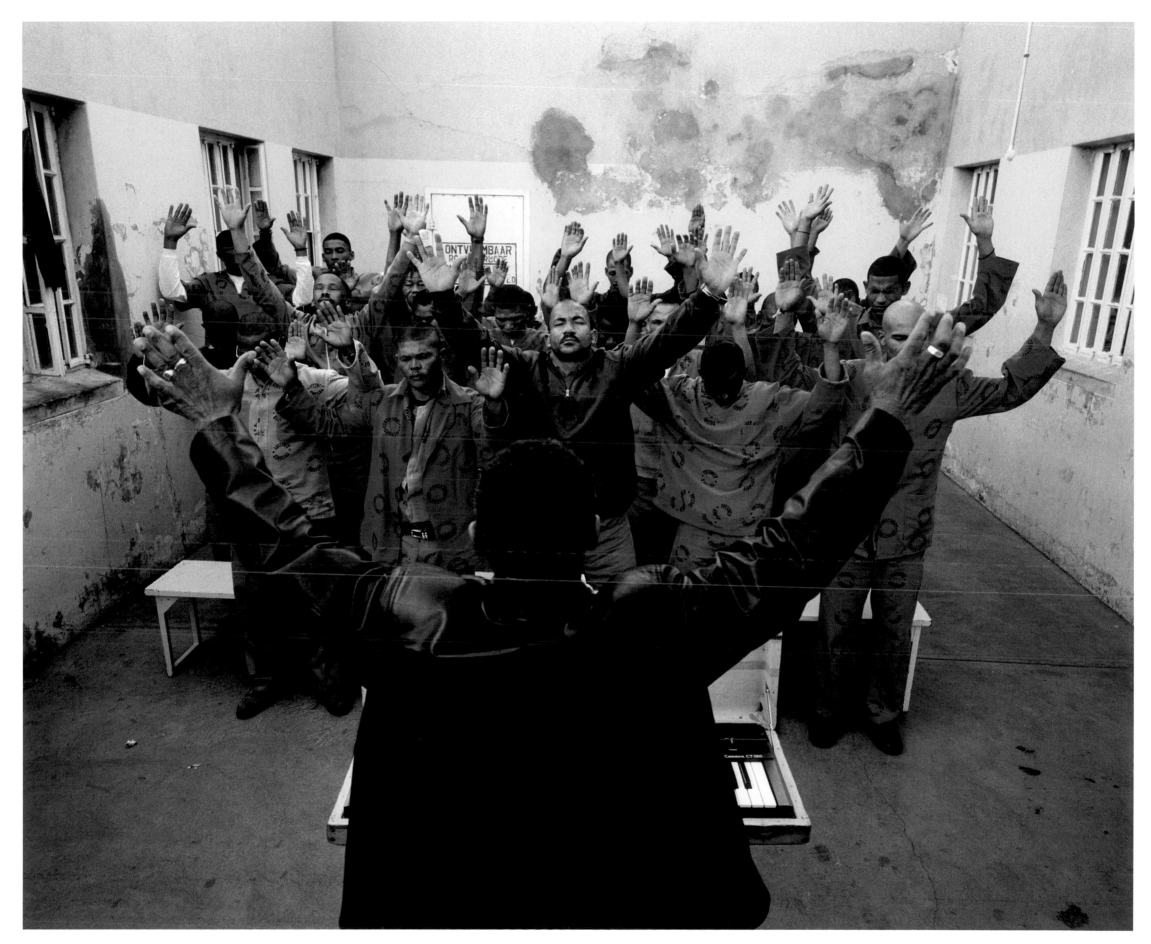

Opposite **Jaco, Beaufort West Prison, 2006** | Pages 76-77 **Exercise yard portrait, Beaufort West Prison, 2007**

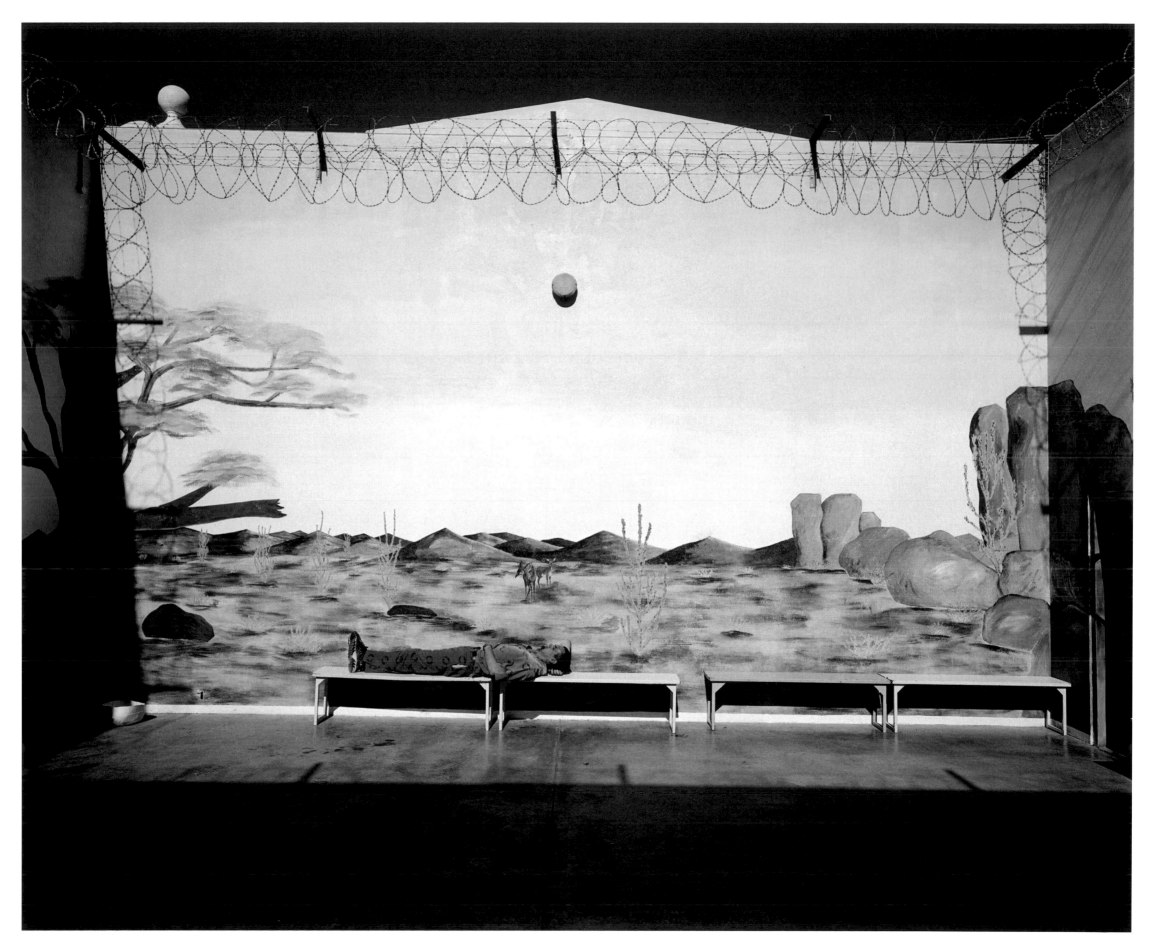

I must have driven through Beaufort West a dozen times, perhaps two dozen, before coming across these photographs, but I had never seen it. That there was a prison in the middle of the traffic circle at the edge of the town centre, that there was a traffic circle at all: I did not recall these things.

I was hardly alone in this. South Africa's longest highway, the 1,200-mile N1 that joins the northern provinces of the country to the south, slices right through Beaufort West, becoming its main street for a short time. Mine was one of several million cars that pass through each year.

Coming from Johannesburg, as I invariably was, two hundred miles of the Great Karoo lay behind me. By the time I got to Beaufort West I carried in my head mile upon mile of scrub-swept desert: a still, empty landscape beneath a vast sky. I was always at the beginning of a holiday, on the way to the coast or the mountains; and the Karoo was something of a foretaste of what lay in store, an early promise of slowing rhythms, of the idea that an entire day might pass without anything in particular to do. Always, somewhere in the Karoo, I would pull off the highway, drive along a dirt road far enough to kill the sound of the traffic, and get out of the car. I'd take in this huge, still space, its receding power lines, its sudden, sharp-edged hills, its benign indifference to me.

Beaufort West was a scruffy, ugly interruption, a brief absence of landscape, rather than the presence of something else. Traffic circle, prison: these I did not see. My mind had slammed itself shut on the edge of town.

And yet, when I first saw Mikhael Subotzky's photographs, they were instantly recognisable. My first thought was 'Of course'. The prisoners in their orange overalls, the hunter's corpses strung up on his truck, even the anarchically coloured debris on the rubbish heap and the huddle of figures who live there: it all seemed utterly familiar. For these photographs give expression to something one understands – even while choosing to forget – whenever one passes through a distant rural town: that the South African countryside has lost the discrete identity it once possessed; that it is becoming a repository for the people and things the cities cannot contain.

Rural South Africa has emptied over the last couple of generations. The number of commercial farmers has declined by almost a third. More and more of those who remain have mechanised their work and employ fewer and fewer people. As for the rural poor, everyone goes to the city. Whether with their family's consent or on the sly, whether alone or with others, scores of young people leave sometime in their teens. It is unusual these days for a person to reach adulthood with visions of spending the rest of their life in the countryside.

And so towns like Beaufort West are increasingly inhabited only by the young, the old, and those who haven't made it elsewhere. The lives of these last follow an endless loop as they move from rural town to city, city to rural town. Drifting from one to the other, they find traction in neither.

To spend the better part of one's adult life in rural South Africa is, for many, to have lost control over one's trajectory. These photographs thus represent a place in which far too many people do not possess the basic structure of what we regard as an inhabitable life: a sense of life as a project, or at any rate as some sort of progression; the notion that one might leave a legacy, or build something that survives one's death. Not long ago, the South African countryside did play host to many such inhabitable lives. Its emptying of people and meaning has coincided, more or less, with the end of apartheid. This is no accident. The economy of the countryside was hardly built to last. It was always an illusion that black South Africa could be confined to a perpetually rural existence, an illusion invented by people who did not bother to think more than a generation ahead. That apartheid has bequeathed to democracy a rural landscape in deep, probably irreversible, decline is no surprise.

You can see the trouble Beaufort West lives with in the thin abstraction of statistics. Two-thirds of its adult residents have no work. And in this town of 37,000, more than 20 people have been murdered in a year: a hair-raising homicide rate of 60 in every 100,000. That's nearly 10 times the New York rate, 20 times that of London, and one and a half times that of Johannesburg, among the most dangerous places on earth.

Jonny Steinberg

Which brings us back to the prison on the traffic circle. Thousands of travellers like me may not have seen it, but this was the spectacle that initially caught Subotzky's eye, giving him cause to stop in Beaufort West and take out his camera. Once you think about it, the very idea of this prison, slap-bang in the middle of South Africa's most travelled national highway, is so bracing you're not sure whether to find it funny, tragic, or simply insane. It seems less a piece of reality than the work of a comic artist straining to capture this town's relation to the world that passes through it. For here is somewhere increasingly forgotten by post-apartheid South Africa. And yet those who inhabit the country's metropolis pass through in their millions; and those who are failing most miserably here, who wind up again and again in the town's jail, get to rotate between a life in the township and a life in the middle of the highway, quite literally listening to the traffic of an economy in which they can find no place. It is as if a never-ending jamboree is passing through Beaufort West, and those most embittered by the spectacle have been sentenced to sit in front-row seats.

If the image of the prison in the road is indeed so sharply burlesque, and the story it tells so instantly complete, why did I never notice it? I guess because I was always on the way to the mountains or the sea, and because the Karoo is so deeply beautiful. We urban South Africans are very proud of our countryside. We rejoice that our cities skirt the edge of a great wilderness, that there are mountains and oceans and deserts just out of sight. I do not know anyone in Johannesburg or Cape Town who isn't a part-time fisherman, or a mountain climber, or the owner of a kayak or a canoe, or who does not spend a part of each year in a house looking out over the ocean. The countryside and the sea live in each one of us. That we have just been there, or will soon go, to empty our minds, is a part of who we are.

The hinterland is thus sacred space, after a secular fashion: out there one communes with whatever passes in one's mind for the spirit world. It is not an easy space in which to imagine the lives of the poor and the struggling. You can know that they inhabit it, but imagining them there is a different matter. It is easier to think of South Africa's wretchedness as something that has been deposited in the cities. And so after several hours of the Karoo, this great desert all around you, you do not have a place in your mind for Beaufort West.

Which is partly why Subotzky's photographs give you the sense that you are looking at something you have always known and yet have never seen. It is not just that the Karoo landscape in his pictures is inhabited. It is that the landscape is so patently a backdrop to the imaginings of the people in the photographs. They are using it: to transport themselves, to elevate themselves, to re-describe themselves. In picturing them Subotzky does more than simply stitch the desert and the people back together. He takes us on a sometimes disquieting adventure, asking us to imagine how the desert is imagined by those who live there.

Almost every photograph carries a suggestion of theatre, and almost every theatre uses the desert as its stage. The boy on the rubbish heap who has donned the Spider-Man mask he found in the trash; the children launching the white sheet into the wind; the screaming man and the princess on their manicured horses; the white girl with the competition tag and high heels on the black-floored stage, posing for an audience off-camera; the snake and the elephant staring so very sweetly at the ill man on the bed; the prisoner lying beneath a massive mural of cacti and sand and stone, like a giant bubble representing the inside of his mind.

In each photograph the subjects transport themselves elsewhere: where, precisely, we are not sure.

For one photograph it seems possible to imagine quite vividly what its subjects are imagining: the panorama group portrait of the prisoners in their orange inmate overalls. This is also the photograph I find most affecting. It is not just the obvious delight they take in the portrait, evidenced in the warmth and playfulness of their inscriptions. Beyond that, the picture is striking because there is little to suggest that it was taken in Beaufort West. The cartoonish iconography of the sunrise, the number '28', the way the two men next to

Dogg and Tamatie wear their woollen hats: this photograph could have been taken in a big Cape Town prison, the inmates all men from the ghettos on the city's south-eastern periphery, the desert mural behind them representing the longings of urban men for open space. They could easily be Capetonians imagining themselves in Beaufort West.

It would be foolish, of course, to get carried away by this idea. Amidst the levity in the photograph there is a whiff of something forlorn and unhappy: this small prison in the middle of a traffic circle in a one-horse transit town, its inmates modelling themselves so studiously on the fearsome rulers of Cape Town's bleakest ghettos.

And yet, since the icons they have chosen are so stark, their meanings so widely shared, it can be conjectured with some certainty that in their minds if not on their lips is a man called Nongoloza, the part-historical, part-mythical figure on whom all of South Africa's great urban prison gangs base the story of their own beginnings.

In the tale the gangs tell of him, Nongoloza is a young black man who finds himself at the fount of modern South African history. Gold has just been discovered, and the whites who own the mines are sending blacks deep into the ground to fetch it. Nongoloza refuses to do that. He recruits a band of followers, retreats to a cave on the outskirts of the mining town, and comes out at night to steal and pillage the very gold the whites have accumulated. And so Nongoloza becomes an outlaw, the most wanted and most dangerous man in the land. As his fame grows, so young black men start seeking him in droves, and the ranks of his bandit army swell and swell.

From the names they have chosen and the icons they have drawn, it is clear that this story plays in the minds of every man in the photograph. Sitting for a group portrait in a prison in unremembered Beaufort West, they have imagined themselves into a central seam of South African history. They are free and dangerous, with vengeance on their minds and justice in their hearts.

New York, April 2008

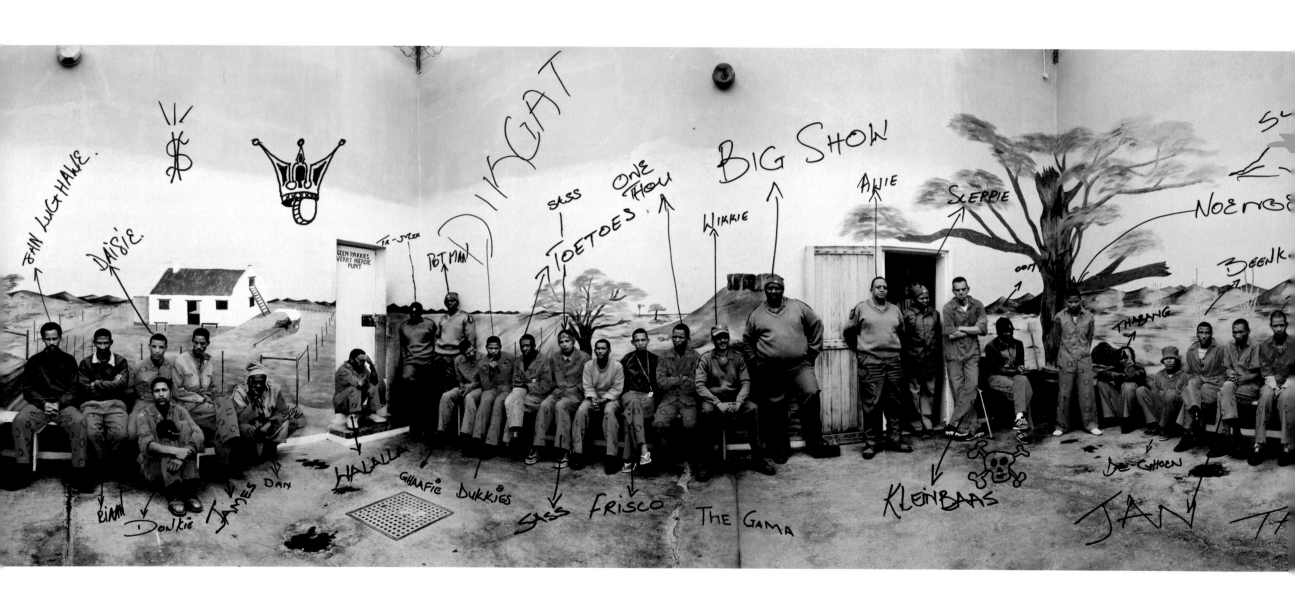

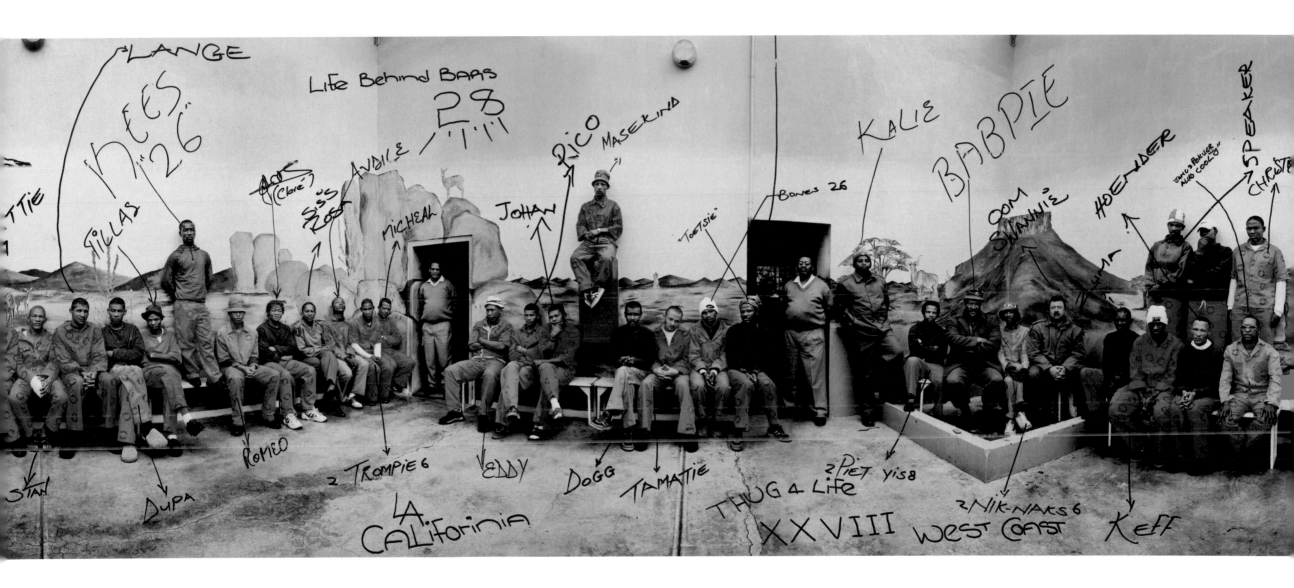

77

Commentary

5 I started making work about South Africa's prisons in 2004 with a series called *Die Vier Hoeke* (The Four Corners), which I did at art school. This looked at the historical role of South Africa's prisons, and the role they were playing in society ten years after the country's first democratic elections. I followed that up a year later with a series about ex-prisoners, *Umjiegwana* (The Outside), where I sought to put the conditions inside prison in the context of the social conditions outside prison. You know, we like to see prisons as separate from society; but with constant movement in and out, they are really a central part of our society. The work I did was in response to thinking about my life and how the fear of crime was affecting all of us in South Africa, across the social and economic spectrum. Even though prison is the end point of the criminal justice system, it felt like a good place for me to start.

I decided to do a portrait of a small town, a small South African rural town, looking at the issues of incarceration and social marginalisation. I was inspired by the tradition of photographic portraits of small towns in South Africa, and in particular by David Goldblatt's book, *In Boksburg* (1982). *In Boksburg* took a very different angle, but I was interested in how it told a powerful social story by exploring one particular place largely ignored by the outside world. My idea was to start with a small town prison and work outwards from it, into the rest of the town. I chose Beaufort West after I learned about the prison being right in the middle of town, and, remarkably, in a traffic circle in the middle of the national highway that passes through town. The image of the town radiating out of the prison was what really drew me to work there.

I started work in 2006 by knocking on doors. One of the first people I met was the social worker at the prison, Mayvoreen Johnson. I needed a combination of assistant, translator, bodyguard and fixer, and she immediately said I should speak to 'Major', a friend of hers. So I met Major, who was a very popular guy in town. He'd been a local soccer star, and he knew everyone, across all the social divides. He subsequently became an extremely important part of the project. He took on all those roles, and also became a very good friend. While I worked in Beaufort West he was with me the whole time, sometimes 24 hours a day. He made it possible to go everywhere and meet everyone and hang out, and it's through him that the project is what it is.

7 This is a view of what are called 'RDP houses' in South Africa, a reference to the Reconstruction and Development Programme which was brought in by the ANC when they came to power, to provide cheap homes and create jobs. The houses are quite famous for being small and depressing, each just a concrete box with a tin roof. But bleak as they were, people would move in and within a couple of months make real homes of them, painting, erecting fences, planting gardens, and setting up spaza shops and shebeens and poolhalls in corrugated iron lean-tos. This suburb of Beaufort West is called Toekomsrus, which is Afrikaans for 'future rest'. When I went around with the police, we'd often end up here because this is where a lot of Beaufort West's crime took place.

9 You come to this very basic motel as you approach Beaufort West from Cape Town. The town is about five hours' drive from Cape Town, ten from Johannesburg, and it's the main fuelling point on the highway. It's also where you turn off the main road if you are going from either city to the Eastern Cape, the former Transkei, one of the traditional 'homeland' areas and the largest of the Bantustans of the apartheid era. There is a long history of migration from the Eastern Cape to the big cities, and because of that, there's now a constant flow of people through Beaufort West heading back to their traditional homes. Almost everybody who comes from the Eastern Cape still has a kraal and a homestead there, they still go back to be initiated and bury their dead there. And a lot of the poor working class in Cape Town, when they need to go home, have to do it over a weekend, which involves a mad dash across the country, driving twelve hours in each direction. So they drive all through the night on a Friday night, spend Saturday and Sunday in the Eastern Cape, and then drive back on the Sunday night. What this means is that Beaufort West comes alive on Friday and Sunday nights, with hundreds of taxis passing through. They all stop at one petrol station, and there's a lot of craziness, with long queues and children selling snacks and people drinking whisky, and church groups singing on their way to a funeral. On Friday afternoons you see people wheeling huge shopping trolleys overflowing with fruit to the petrol station. It's an amazing, vibrant scene, and a major part of the town's economy.

Overall, my experience of Beaufort West was very mixed. It's a town rich in social traditions, and I met and got to know many wonderfully warm and dynamic people there. But it is also one of the bleakest places I have ever been to, sometimes feeling like nothing more than a junction on the highway. These motel rooms are near the town's truck stop, an area notorious for the local prostitutes who service the transient community.

13-15 Starting with Samuel, who's wearing a Spider-Man mask he found in the rubbish, these next three photographs were taken at the town's municipal dump, Vaalkoppies, which in Afrikaans means 'grey hills'. The donkey cart in the third picture is loaded up with rotten fruit picked out from the rubbish for selling to farmers as pig food. I was at the dump on a day when rubbish is collected in town, and a truck would arrive every fifteen minutes. There's a group of about thirty people who live at the dump (you can see their shacks in the background of the picture on page 14), and on collection days others come from town, too. I spent some time sitting in one of the shacks talking to people. Someone would always be watching for the next truck, and whenever they heard one coming, they'd call out something and everyone would run to be on the spot as it dropped off its load. One time, I was confused because the lookout heard a truck, and called out, but no-one moved. I asked why no-one was running after it. I was told it was 'die bene lorry', the bones lorry. This was the truck with the rubbish from the townships. There would be nothing but bones in it, so it was not worth bothering with.

17-19 I think it was on my sixth or seventh trip to Beaufort West that I went to the agricultural show. I really wanted to be there because of the special place these shows have in the culture of small towns, and I raced down from Johannesburg to get there in time. All the surrounding farmers bring in their best cows and sheep and horses to be judged, and everybody dresses up in cowboy hats and those funny cowboy ties, and there's a fancy-dress competition. It's a real occasion. Shows like this are at the heart of the traditional white Afrikaans farming community. At the dance afterwards, Major was the only black guy there. But there's also a strong tradition of black and coloured involvement in the shows, and the guy who won the Champion of Champions horse-riding competition that day was a coloured guy.

I know 'coloured' is a problematic term in the rest of the world, but the coloured community in South Africa is distinct and real, and we don't have an alternative word. This is a legacy of people of mixed-race descent being segregated from both blacks and whites during the apartheid era. By the looks of things, Beaufort West still seems a very divided town – and it is. The nicest areas in the town and surrounding suburbs are still mostly inhabited by whites. And the outlying townships are black and coloured. In 2005, the South African Human Rights Commission did a study on the town because there were more and more reports of child prostitution and other social problems. They described it as 'an isolated town that has not broken away from the shackles of South Africa's apartheid past, and economic and social integration is severely limited'.

21 The hunter here provides a service for farmers by shooting jackals and caracals. These animals are seen as pests because they sometimes kill sheep.

22 The guy behind the desk is Mr Rossouw. He's an antique dealer. He has an antique shop and 'village museum', as he calls it. The pride of his collection are these antique mannequins which he finds and restores. He even dresses them himself.

23 The history of Beaufort West fascinates me. In the days of the Cape Colony, there were armed bandits in the area who would hijack travellers and steal from the farmers. And that's the reason the town was established – to bring the area under the control of the state, with a courthouse, a police station, a prison and a church. One of the defining features of its more recent history, and a source of civic pride, is the fact that Chris Barnard was born here, the man who did the first ever heart transplant, in 1967. He became a national hero during the apartheid era. His father was the local pastor, and in the church now they've made a museum in his honour. It includes this diorama of figures recreating the heart transplant, which took place in Cape Town at Groote Schuur Hospital. This guy was cleaning the diorama on the day I was there.

27 This photograph is in the veld where a traditional healer called Thandi was performing the final part of a healing for a woman who was ill. She was happy to show me what she did. We all got in a car and drove out to this spot where they cut off the head of a chicken and buried its body beneath the ill woman's feet. The blood was mixed in a bucket with other medicines and muti, and then ritually poured over her.

29 This was in the house of a policeman. He had a drinking problem and his family wanted to help him stop, so they organised a traditional offering to the ancestors. It involved a big feast where we all ate goat meat. And then the policeman and his mother had to sleep next to the carcass. This is the carcass in the bedroom. I saw the policeman a couple of weeks later. He had a beer in his hands.

35 Major didn't want to come with the day that I went to photograph at this church, because he had heard that a black person had recently been turned away there. Everybody was very warm and welcoming to me when I went alone.

36 Alcohol is really a huge problem in Beaufort West. Much of the crime that happens in the town is alcohol-related. This picture is in a 'pine house', where home-brew is made and served – in this case, in a 5-litre paint can. South Africa has the highest incidence of foetal alcohol syndrome in the world.

37 This picture was taken during 'Allpay', which refers to the payment once a month of pensions, and disability and child support grants. In an ideal society it would be a small percentage of the community who are getting state aid, but just as the name Allpay implies, a lot of people in South Africa rely on this support. Much of the local economy revolves around it. There was a festive atmosphere in Beaufort West that day. From early in the morning people were setting up braai fires and putting up stands to sell meat or cheap clothes. All the debt collectors were there to collect their dues. If you need credit from the shops in town, you give them your social security card and they keep it as collateral. Then at the Allpay hall, you can get your card back from the creditor as you go in, and you have to pay them what you owe on the way out. Allpay in Beaufort West involves handing out literally millions of rand, so there are lots of heavily armed security guards around.
 It's interesting the way South Africa's welfare system affects the dynamic within families. The old and the disabled have significant social clout because they bring in the primary income in a lot of families. It gives a certain sense of pride to older people – which is great – but on the other hand it can seriously distort social dynamics. So you might have a 40-year-old man who would expect to be in control of his finances and be head of the family in a patriarchal way, but he relies on his mother or his grandmother for support. It can lead to a sense of emasculation, and I think that this is very significant in relation to South Africa's high levels of violence and crime.
 A lot of that state money is spent as soon as it is paid out. Many families I know would buy a huge package of food – mainly mealie flour and maize flour and staples that would last them the month. And then they would drink the rest within a couple of days. Some of the families I know best are sober throughout most of the month but then they drink heavily during Allpay weekend. It's a busy weekend for the police.

39 This scene is in Toekomsrus township, where someone has added a tavern with a pool table on to their house.

41 This is also in Toekomsrus township. It was a Sunday morning after a wild night in the town, and I was driving around visiting people with Major. He knew this family, and we stopped and we were greeting each other, and then I noticed the girl had 'Fuck Me' written in ballpoint pen on her forehead. I asked what was going on, and Major explained that the girl's parents had been drunk the previous night and had written it on her as a joke, or some sort of prank.

43 For years (long before I became a photographer), I was fascinated by these neon-lit crosses on the hills above small South African towns. I had tried to photograph this one on numerous occasions but was never happy with the result. I eventually found a spot, and this was the last photo I took on my last visit to Beaufort West. The house in the foreground is part of an area called Hillside. It was originally in the white area, but on the wrong side of the railway tracks. Somebody told me that not long ago, if you tried to get an account at one of the clothing stores and you gave your address as Hillside, they wouldn't give you credit. There's still a lot of stigma around poor whites and this part of town, which is now a predominantly coloured area.

45 This is Joseph. When I met him, he was very sick with TB, which is a very serious health problem in South Africa. He was waiting for an X-ray to be done. He is the distant cousin of the mother in the next photograph. He sadly passed away a couple of months after I took this picture.

47-49 This is the Mallies family, who I spent a lot of time with and got to know really well. I ate a lot of meals with them, and got to know the ins and outs of their lives and their history. They always made me feel incredibly welcome. In the first picture, Joseph is in the background lying there. His wife had kicked him out and he had nowhere else to go. And this was a tiny two-bedroom house where all these people were living. The kids are Biksie and Kaolin. Whenever they heard Major and me approaching they would sprint out the gate and give us bear hugs. The woman singing is Bonita, a cousin of the family who was staying there at the time, and the girl to the right of her is her daughter. The family seldom drinks but they do drink after Allpay and this was one of those occasions. Bonita was singing an old church hymn which made her very emotional.
 The father Marius is slightly disabled so he has a disability grant which supports them. The rest of their income comes from Michelle, in the next pictures, who was 19 when we first met, and who works from time to time at the truck stop. Her father would sometimes walk her to work because it can be unsafe in the area around the trucks.

50 Major and I were hanging out with a group of gangsters, and they were talking about going off to rob someone's house. They thought they were going to find something there that they wanted. To my complete surprise they asked if I wanted to come along. I asked myself a lot of questions in deciding whether to go with them. They told me that somebody had been watching the place and nobody was home, so I was assured that the situation wouldn't end in violent confrontation.

51 I asked Michelle if I could photograph the beginning stages of what went on in the cab of a truck – what I imagined would be some sort of negotiation. It turned out that the discussion and the physical contact were intertwined – as much a flirtation as a conversation.

53 I was going around with the police in their vans when we found this man lying in the street. I thought he was dead when I first saw him. He had been badly beaten up. It turned out he was very drunk but not that badly injured. He'd tried to break into someone's property and got beaten up.

55 Here the police are being called to a dispute in a house where lots of different families live and where someone has been beaten up. Most of the crime and violence in South Africa happens within families and within neighbourhoods, between people who know each other. Most police time is taken up with these kinds of disputes. There's this fallacy that the role of the police is to be the thin blue line protecting good people from bad people, but it's not like that. They get called to domestic disputes or neighbours' disputes, and they get there to find drunken people screaming at each other or fighting, and what they have to do is be there and try to calm the situation. As the writer Antony Altbeker describes, they are asked to be so many things that they're not: marriage counsellors, therapists and so on. A big problem with police morale is that they can't effectively deal with these situations because it's not what they are trained to do and it's not what they see their role as. Crime doesn't always happen across the boundaries that we think it does – it's far more complicated than that.

56 This man was in hospital. He had terrible calluses on his hands. His friends came to visit him and took him around the back of the hospital – drip and all – for a joint.

57 These guys are smoking 'tik', which is slang for meth-amphetamine, or crystal meth, which started to become a feature of South African society in recent years. It's been incredibly destructive. It's highly addictive and very cheap to make with over-the-counter ingredients. It was a big thing in the cities at first, and it's only lately that it's reached the small towns.

59-65 The next four photographs were all taken in the booking area of the police cells. I found this a very interesting space because I've been preoccupied with working inside and outside prison. And here, literally, was the interface – the point between two worlds.

67-77 Finally, we are in the prison. The first picture shows Tamatie. A couple of years ago he was mugged for his money and beaten over the head with a steel rod. Since then he has had a number of health complications, and he started having episodes where he lost control of himself. During one of these, he raped a teenager. He was charged, released on bail, and then the same thing happened again. So at the time I took the picture, he was serving one sentence for one of the attacks and was waiting to stand trial in Beaufort West for the other. That's why he was in their small prison, but where he couldn't get any psychiatric help of any kind. Without in any way wanting to condone his actions, his story speaks to me of something important: as in any society, in South Africa there isn't a distinct victim/perpetrator divide. The problem is that so much of the way crime is represented in the popular media polarises victim and perpetrator, us and them, the law-abiding citizens and those who law-abiding citizens have to fear. I almost see that as a new kind of apartheid – between those that fear and those that are feared. And part of the role I see for my work is to open up these stories and these situations, to try to dissolve these polarised divisions – so that we see all these situations as part of each other.

73 This is Jaco sleeping in the exercise yard of the prison. It was Jaco who painted the massive mural there, with the help of the other prisoners. And it was their idea – this idyllic image of the landscape outside the prison, painted on its inner walls. It is very much a Karoo landscape, a Beaufort West landscape, un-peopled but with animals and beautiful trees and hills. The prison has now had it painted over as a part of their recent renovations.

76-77 This is a 360-degree panorama of the mural and the exercise yard, with all of the prisoners. I asked everybody in the prison to pose for it. I wanted to give everyone a photograph, but if I took a picture of each guy individually it would have taken all my time up, so I thought I'd get them all in one photograph and then just make lots of copies. On one of the later trips I took two 3-metre-wide prints along with me, one of which is now on the wall there. The other one we laid out very carefully on a ping-pong table and all the guys who were still there inscribed it – with whatever they wanted. Some wrote their gang symbols, some wrote their nicknames. For those who weren't there, others wrote their nicknames down for them. It was a lot of fun as everyone covered this big print with their writing and made jokes about how each other looked.

Mikhael Subotzky, from an interview
London, May 2008

Thank you to all those I encountered and worked with in Beaufort West.

Serame 'Major' Metsing was a constant companion in Beaufort West without whom none of this work would have been possible.

Gideon Mendel has been my mentor and teacher since the beginning.

Linda Givon has supported my career with great care and personal commitment.

Chris Boot has had great faith in realising this volume, and great knowledge and insight in bringing it together.

I would also like to thank all those who have supported this project, including Antony Altbeker, Katie Boot, Enrico Bossan, Julia Cloete, Ayperi Ecer, Kate Edwards, Adrian Evans, Kelly Gillespie, David Goldblatt, Florence Hallett, David Hawkins, Claudia Hinterseer, Glenn Howard, David Hurn, Svea Josophy, Mike Kemp, Roberto Koch, Adrian Kohler, Evelien Kunst, Lesley Martin, Alessandra Mauro, Tony Meintjes, Anya Mendel, Eve Mendel, Sean O'Toole, Martin Parr, Di Poole, Fred Ritchin, Kelly Rosenthal, Pippa Skotnes, Frede Spencer, Barbara Stauss, Jonny Steinberg, Walter Stokman and Patrick Waterhouse; Lisa Essers, Emma Bedford, Neil Dundas, Didier Mukendi, Wendy McDonald, Storm Janse Van Rensberg, Kirsty Wesson and all the staff of Goodman Gallery; Hélène de Franchis, Francesco Sutton and everybody at Studio La Città; Mike Ormrod, Vincent Van Graan and the staff at Orms; Francesca Sears and everybody at Magnum Photos; Marloes Krijnen, Colette Olaf, Roy Cremers, Merel Kappelhoff and the staff at FOAM; Charles Griffin, Marisol, Eric, David and everyone at Griffin Editions; and Roxana Marcoci, Peter Galassi, Susan Kismaric, Dan Leers and Eva Respini at MoMA New York.

Finally I would like to thank everyone in Beaufort West for their invaluable help, notably Maxie Kritzinger and Tertia Thomas for their amazing hospitality; Mayvoreen Johnson; Nomahlubi Sithole; Gert Vlok Nel; Mike the pilot; Mr Fisher, Mr Leslie and all the members of staff at Beaufort West Prison; Senior Superintendent Makhubela, Superintendent Kennedy, Inspector Cedras and all the police officers at Beaufort West police station; Medical Superintendent De Plooy at the Beaufort West Hospital; and Wire, Yster, Luyanda, Gerrie, Enjoy, A Team, Themba and the rest of the Plaza Crew.

Mikhael Subotzky
London, May 2008

Mikhael Subotzky was born in Cape Town in 1981. He graduated from the Michaelis School of Fine Art at the University of Cape Town in 2004, where his final-year project, the series *Die Vier Hoeke* (The Four Corners), was an in-depth photographic study of the South African prison system. In 2005, Subotzky extended his focus on criminal justice by running photographic workshops with prisoners and photographing former prisoners for a series titled *Umjiegwana* (The Outside). *Beaufort West*, his third major project, has been the subject of exhibitions at FOAM, Amsterdam, in 2007, and the Museum of Modern Art, New York, in 2008. He is represented by Goodman Gallery, Johannesburg, and Studio La Città, Verona, galleries where he has exhibited since 2005.

In 2007, Subotzky joined the Magnum photographers' co-operative as a nominee member. His major awards include the Special Jurors' Award at the VIes Rencontres Africaines de la Photographie in Bamako, 2005; the F25 Award for Concerned Photography, Milan, 2006; the KLM Paul Huf Award, Amsterdam, 2007; the Young Photographer's Award, VISA Festival, Perpignan, France, 2007; and the International Center of Photography's Infinity Award (Young Photographer), New York, 2008.

Subotzky's prints have been collected by museums including the South African National Gallery, Cape Town, the Johannesburg Art Gallery, and the Museum of Modern Art, New York. *Beaufort West* is Subotzky's first book.

Jonny Steinberg was born in South Africa in 1970 and educated at Wits University in Johannesburg, and at Oxford University, where he was a Rhodes Scholar. He is the author of several books about everyday life in the wake of South Africa's transition to democracy. Two of these, *Midlands* (2002), about the murder of a white farmer, and *The Number* (2004), about a Cape Town prison gangster, won South Africa's premier non-fiction literary award, the Sunday Times Alan Paton Prize. A collection of Steinberg's essays, *Notes From a Fractured Country* (2007), was based on the newspaper column he wrote for *Business Day* over a six-year period. His latest book, *Three-Letter Plague* (2009, published in the USA in 2008 as *Sizwe's Test*), chronicles a young man's journey through South Africa's AIDS pandemic. Steinberg now lives in New York, where he is writing a book about the city's African immigrants.

Beaufort West
by Mikhael Subotzky
with an essay by Jonny Steinberg
© Chris Boot Ltd 2008

First published 2008
in an edition of 3000 copies
by Chris Boot

Chris Boot Ltd
79 Arbuthnot Road
London SE14 5NP
United Kingdom
Tel +44 (0) 20 7639 2908
info@chrisboot.com
www.chrisboot.com

Photographs © Mikhael Subotzky
Essay © Jonny Steinberg

Project manager Florence Hallett
Design by Untitled

Distribution (except North America)
by Thames & Hudson Ltd
181 High Holborn
London WC1V 7QX

A CIP catalogue record for this book is available from the British Library.

ISBN 978-1-905712-11-3

Printed in Italy

Boot